THE DISAPPEARANCE OF DARKNESS

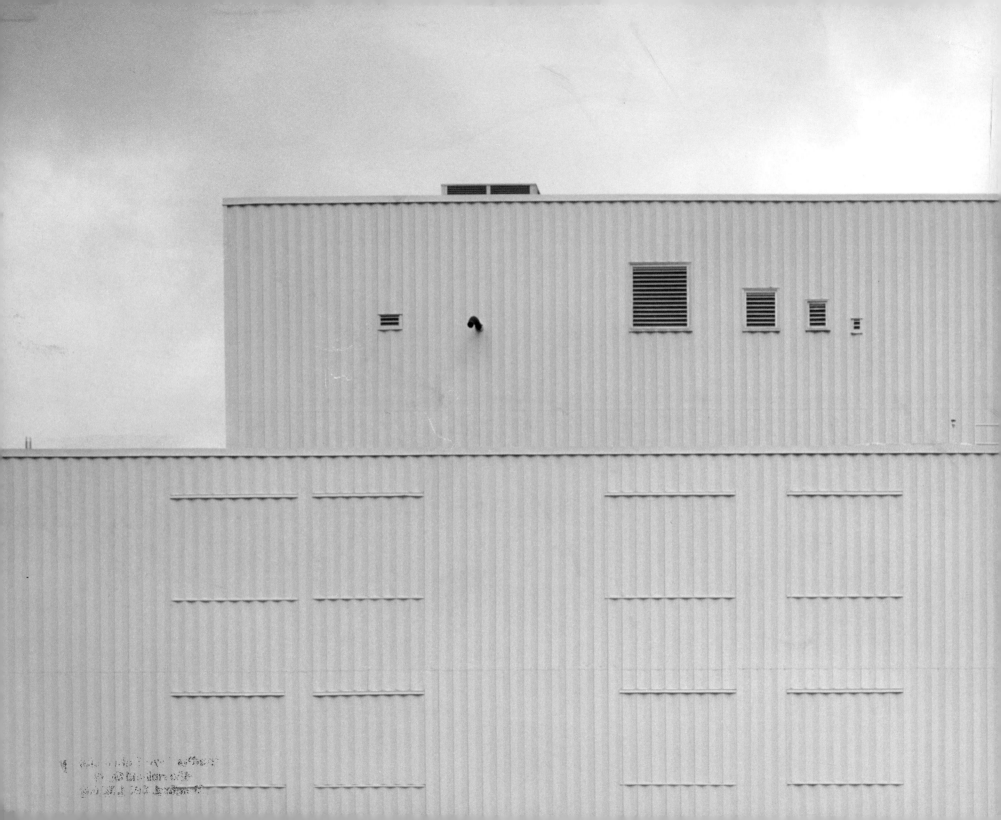

ROBERT BURLEY

THE DISAPPEARANCE OF DARKNESS
Photography at the End of the Analog Era

Princeton Architectural Press, New York | Ryerson Image Centre, Toronto

for Debra and our boys Nate, Joseph & Eli

Published by Princeton Architectural Press
37 East Seventh Street
New York, New York 10003
Visit our website at www.papress.com

in collaboration with

Ryerson Image Centre, Ryerson University
33 Gould Street
Toronto, Ontario M5B 1E9

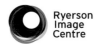

Editor: Dan Simon
Designer: Linda Eerme

Special thanks to: Bree Anne Apperley, Sara Bader, Janet Behning, Nicola Bednarek Brower, Fannie Bushin, Megan Carey, Carina Cha, Andrea Chlad, Benjamin English, Russell Fernandez, Will Foster, Jan Haux, Diane Levinson, Jennifer Lippert, Jacob Moore, Gina Morrow, Katharine Myers, Margaret Rogalski, Elana Schlenker, Sara Stemen, Paul Wagner, and Joseph Weston of Princeton Architectural Press
—Kevin C. Lippert, publisher

Library of Congress Cataloging-in-Publication Data

Burley, Robert, 1957–
The disappearance of darkness: photography at the end of the analog era / by Robert Burley. — 1st ed.
 p. cm.
Includes bibliographical references.
ISBN 978-1-61689-095-7 (hardcover : alk. paper)
1. Architectural photography—Exhibitions. 2. Factories—Pictorial works—Exhibitions. 3. Photographic film industry—History—Exhibitions. 4. Burley, Robert, 1957—Exhibitions. I. Ryerson Image Centre (Toronto, Ont.) II. Title.
TR659.B864 2012
770.74'713541—dc23

2012016171

CONTENTS

FOREWORD

Robert Burley is one of Canada's leading artists working in photography. His inspiring photographs of urban architecture and landscape have been exhibited and collected nationally and internationally. He has worked on documenting the demise of film-manufacturing facilities and industrial darkrooms since 2005. This project speaks to a historical moment of no return, or to what Burley calls "the dizzying moment in photography's history in which technological changes redefined the medium forever."

In both his moving and personal essay and his photographic œuvre, Burley looks at the end of celluloid with nostalgia while remaining open to experimentation, and the potential of innovative photographic materials, modern technology, and unexpected, sometimes even spectacular, spaces in which to display his photographs. In 2008 and 2009 Burley created two large-scale, site-specific photographic murals showing crowds of anonymous individuals observing the implosion of Kodak factories in the United States and France. The planned end of film photography was commemorated through monumental installations made with a new digital medium at the cutting edge of current print technology. The 2009 piece, *Photographic Proof* (illustrated on the facing page), an 18 x 66 foot film mural adhered to the north facade of the Canadian Centre for Architecture for the Mois de la Photo à Montréal, functioned as an allegory of the disappearance of traditional technologies.

As Andrea Kunard points out in her essay, the digital era is redefining the relationship between art, photography, and industry. The shift from analog to digital and its major economic impact have transformed the creation and dissemination of photography, but also modified the definition of the medium itself. In his essay on Kodak's financial downfall, François Cheval recalls how, at the end of the nineteenth century, the company became a dominant force in the photography market by simplifying technological processes and taking full advantage of the U.S. Patent Office. The Kodak factory built in Chalon-sur-Saône, France,

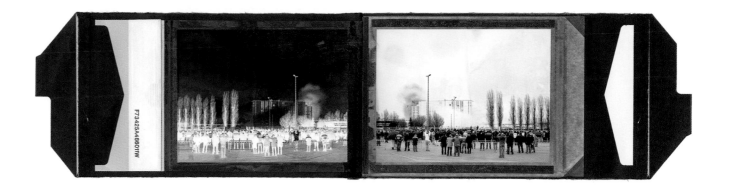

in the 1950s became a symbol of this history, from its architectural might to its implosion in 2007. Alison Nordström, writing more specifically on Burley's photographs, examines how his work documents both the dramatic and historical disappearance of a significant industry and the "human-scale remnants" of this technology.

This book is the first step in a long-term collaboration between the Ryerson Image Centre and the artist, who teaches at the School of Image Arts, Ryerson University. It will accompany the exhibition, *Robert Burley: The Disappearance of Darkness*, produced by and exhibited in our Centre in 2014. The exhibition will tour internationally in the coming years, with venues in Canada, the United States, and Europe.

The Ryerson Image Centre extends its warm thanks to the artist, Robert Burley, and to François Cheval, Andrea Kunard, and Alison Nordström for their invaluable contributions to this publication.

DOINA POPESCU, DIRECTOR
GAËLLE MOREL, EXHIBITIONS CURATOR
RYERSON IMAGE CENTRE, RYERSON UNIVERSITY, TORONTO

ACKNOWLEDGMENTS

While my photographic surveys are solitary pursuits, I rely on numerous organizations, institutions, and individuals for help along the way. The production of the book itself was a collaborative endeavor that drew in many personal and professional friends whose support, guidance, and contributions also need to be acknowledged.

First, I would like to thank the Canada Council for the Arts, Ryerson University, the Mellon Senior Fellowship Program at the Canadian Centre for Architecture, and the Howard and Carole Tanenbaum Family Charitable Foundation for their support and recognition of my work.

I am thankful to all those people who welcomed me into their businesses and homes, and allowed me to make photographs for this project: André Bosman, Steven Brierley, Elsa Dorfman, Bruce Horsburgh, Johan Jacobs, Joan and Nathan Lyons, Dwayne and Grant Steinle, Andy Taylor, and Christopher Veronda.

Numerous friends including Phil Bergerson, Gary Hall, Geoffrey James, Phyllis Lambert, Bob Shanebrook, Don Snyder, Maia Sutnik, and Henry Wilhelm have provided me with essential feedback. I'd also like to thank my dealer Stephen Bulger and curators Louise Désy, Felix Hoffman, Lori Pauli, Bonnie Rubenstein, Ann Thomas, and Mirko Zardini for supporting my work in the early stages of development as well as featuring selections of this project in their exhibitions and institutional programs.

My studio assistants at Ryerson University have helped with an endless list of tasks that has supported my photographic work and exhibitions—without their support I would be lost. Ben Freedman, Sabrina Maltese, Elena Potter, and Cameron Smith each deserve recognition for their work on this project, and Michelle Wilson deserves a thank you for assisting with the final phases of photography and image processing for the book. I also thank Jay Teitel and Rachel Verbin for their editorial support.

Publisher Kevin Lippert, editorial director Jennifer Lippert, editor Dan Simon, and everyone else at Princeton Architectural Press have been a delight to work with in terms of making the idea of this book a reality.

I am deeply indebted to Doina Popescu, Director, and Gaëlle Morel, Curator of the Ryerson Image Centre for their crucial support of, and contributions to both the book and exhibitions. I would also like to thank curators, François Cheval, Musée Nicéphore Niépce; Andrea Kunard, National Gallery of Canada; and Alison Nordström, George Eastman House International Museum of Photography and Film, for their insightful essays as well as collaborating on related exhibition projects.

Finally I must acknowledge my enormous debt to two friends who have been instrumental in shaping this book: Linda Eerme and David Harris. David has, for many years, been my constant sounding board for all things photographic and curatorial. Linda became a full-fledged collaborator in this project over a two-year period, working on all aspects of the book from image selection and sequencing with David through editing my earliest texts. She was responsible for the concept and layout of the initial maquette and for designing the final publication. As always, I am thankful to these friends for their support, patience, and honesty.

THE DISAPPEARANCE OF DARKNESS

Robert Burley

The past went that-a-way.... We look at the present through a rear-view mirror. We march backwards into the future.

Marshall McLuhan Understanding Media 1964

THIS BOOK IS MY OWN MARCH BACKWARDS INTO THE FUTURE. IT TELLS THE STORY OF AN INDUSTRY that was obliterated by the creative destruction of the digital age. This industry not only shaped my work as an artist, but also touched millions of lives with its magical products, helping define what the twentieth century would look like and how it will be remembered. The work presented here is a photographic survey created in a post-photographic age: the result is a book about what photography once was—as a technology, an enterprise, and an art form. It is a record of the dizzying moment in photography's history in which technological changes redefined the medium forever. It is also an account of my own transition from industrial to information age; one that demanded I play the dual role of participant and observer.

Over the last decade, the medium of photography, my life's work, has been utterly transformed, radically and irrevocably. Think of the megaphone and the telephone, the horse-drawn carriage and the car: new technologies replacing old ones and in the process changing not only the way we are conveyed to our destination (a place, a feeling, a vision) but the destination itself. It is now clear that the dark, chemical, and physical photography that I knew in the first part of my life, will not survive into the next. My own experience with making photographs, one that involved not only seeing, but also touching, smelling, and navigating my way around darkrooms with trays of chemical baths and "safe" lights is all but gone. It has been replaced by universal electronic tools, which allow me (some would say force me) to manipulate dematerialized data on a glowing screen.

As Marshall McLuhan suggested, we cope with change through a backwards gaze; our perception of the future may lack definition, but if we're lucky, we may momentarily glimpse a remarkably clear view of the evocative past just before it fades into history. When McLuhan published *Understanding Media*, I was a grade-school student in small-town Ontario where I lived through the 1960s, a decade of enormous technological and social change itself. At the time I had little regard for the past and a great hunger for

13

the limitless future. Now in my mid-fifties, and once again in a period of massive change, when by rights I should be mesmerized by the wonders to come, I find myself drawn irresistibly backward, to my past and the larger past that nourished it. When I began the project, I couldn't decide which was more poignant: the emergence of a new technology that irrevocably changed my medium or the abrupt and traumatic breakdown of a century-old industry that embodied photography's material culture. Both happened rapidly and triggered a string of conflicting emotions, including anxiety and nostalgia, bewilderment and awe, astonishment and melancholy.

All photography is about loss. Any act of taking a picture is underscored by a desire to record something on the verge of change or disappearance. We use the camera to stall (or at least slow down) time, making images of the present for recall in the future, either because we don't trust our memories to absorb or our minds to grasp what a moment was. Since photography's invention, this indexical relationship to time and reality has been the medium's currency. It has allowed us to look at the past through eyes that could only dream of what might lay beyond the moment a photograph was made.

As recently as ten years ago, I could not have dreamt that Kodak Heights, Kodak Canada's manufacturing complex in Toronto, the city where I now live, would be shut down for good in 2006. It was the tip of the iceberg. Six years on, I realize how little I knew then about the disappearing world that has preoccupied me since that time: the photographic industry. All photography was once about darkness, both literal and figurative—no other medium was predicated on it; darkness made photography unique. In the literal sense, both the production and processing of light-sensitive materials, photographic films and papers, required darkness. Figuratively, the companies manufacturing these materials have always operated in the dark, guarding a secret world of patents and high profits from those who might want to steal those alchemical formulas and methods.

While there have been only a handful of companies that manufactured photographic films and papers over the last century, their sheer size and reach would have made any kind of comprehensive history of the industry unworkable. Instead, what I set out to do was chronicle my own relationship to this world. The companies and sites I chose to photograph were all a part of my own history. My connection to the places and events in this book is a personal one, as an artist whose work depended on the materials manufactured in these mammoth and windowless buildings.

My investigation began in 2005, the year I learned that Kodak Canada's parent company, U.S.-based Eastman Kodak, had decided to close down the Canadian operation in response to a steadily shrinking demand for its traditional photographic products. Intellectually, this should have come as no surprise; it was clear by this time that as the use of digital cameras increased, there was a corresponding effect on film: many amateurs and professionals alike no longer bought photographic film. The shift to digital appeared inevitable. What could the industry do but downsize?

But I was a photographer and, after all, this was Kodak. It was unthinkable that the iconic name that had become synonymous with photography itself could disappear. I immediately applied for, and was

granted access to take pictures of the plant in Toronto before it closed. In my first days of photographing at Kodak Canada, I spoke to workers—from chemical engineers to administrative assistants—who were in shock and disbelief. The company had been a lifetime employer, and the announcement of the plant closing had shaken them to the core. It felt like speaking with someone who was trying to absorb the unexpected death of a close family member.

To create my photographs of the plant, I decided to use film, the material that had for decades been manufactured inside these very buildings. My motives were not fuelled by sentimentality; at that time, film was still the medium of choice, the one I knew would deliver the best results. In making these pictures, I caught the first glimpse of what now, with hindsight, seems impossible to have missed: the degree to which the industry supporting analog photography was threatened by a perfect storm of social, economic, and technological change.

The key to that storm, and to the vulnerability of Kodak and companies like it, was the economy of scale. When the company's founder George Eastman introduced his Kodak camera in 1888 with the slogan, "You press the button, we do the rest," he knew that if his invention were to succeed, it would need to be adopted worldwide. By simplifying and reducing the cost of what had been a complex, expensive, and cumbersome process, Eastman believed he could convince a global clientele to take up photography and buy his products. He succeeded magnificently; by the 1920s, photography had become a ubiquitous multi-faceted tool used to commemorate family occasions and exotic places, to record wars and scientific marvels, to create image inventories of the everyday world, and to provide a medium for artistic expression. For the next eighty years, Kodak's supremacy was unchallenged. But then the century turned; at the dawn of the new millennium, algorithms began to replace chemistry in photographic production, and Eastman's roll film became not only anachronistic but also unsustainable without its enormous customer base.

I now know that when I began photographing at Kodak Canada in 2005, I was documenting not just the decline of film but its disappearance. After spending eighteen months shooting the evacuation, decommissioning, and demolition of the plant—the architecture of this darkness—I turned my attention to similar companies and events. In 2007, I witnessed and recorded a series of scheduled implosions of film factories by the Kodak Company: first in Rochester, New York, the company's birthplace (1888); and then in Chalon-sur-Saône, France, the birthplace, in 1827, of photography itself.

Each time I attended one of these implosions, I knew I was watching history. The moments were both sad and sublime—and ironic. At each implosion I found myself photographing not just the unreal spectacle of enormous structures reduced to dust in a matter of seconds, but also the spectators—many of them former Kodak employees—who were invariably recording the events with digital devices, with technology that used memory cards instead of film. In almost all instances, I was the only photographer documenting these poignant occasions on film.

After concentrating on Kodak, the world's largest manufacturer of photographic products, I began to include the other companies whose materials I had also used. In 2007, I gained access to the central

facility of Agfa-Gevaert, a company founded in 1867 and located just outside Antwerp in Belgium. (By this time Agfa Photo, famous for its rich black and white films and papers, had declared bankruptcy and shut down its factory in Leverkusen, Germany; in Belgium, the parent company maintained production only of its specialized medical and aerial films.) Two years later, in 2009, I photographed what remained of Polaroid's Massachusetts factory, which had been sold and gutted after the company ceased all production of its instant films one year earlier. In 2010, I visited an Ilford plant situated in the English countryside just outside of Manchester. Founded in 1879, the U.K.-based Ilford had been forced into bankruptcy in 2004 and was subsequently restructured by a team of company executives who continued (and continue, as of this writing) to manufacture black and white photographic film and paper in the face of a rapidly declining market.

At the end of December 2010, Dwayne's Photo Lab in Parsons, Kansas, the last photographic lab in the world to process Kodachrome, accepted its last rolls of film; it was an event I wanted to document. The trip to Parsons quickly became a photographic pilgrimage that was shared by more than a hundred others who arrived from around the world to witness one of analog photography's final gasps. I was surprised not only by the number of photographers, artists, and enthusiasts who made the long drive (or took the longer flight), but also by the nature of the day. Dwayne's took on the air of a social club, not unlike other photographic labs I had used in past years. Like them, it too became a place to fraternize with other photographers dropping off or picking up film from their latest shoot. And the conviviality was heightened by the finality of the day; this was the last drop-off. Very quickly it took on the feel of an Irish wake for a longtime friend.

Pulling out my view camera and tripod, I experienced a new feeling myself. Somehow, over the course of this project and without my being fully aware of it, my photographic equipment had become outmoded and antiquated, at least to my eyes; my view camera suddenly looked like a Victorian contraption. This is difficult to explain: perhaps it is something of a double déjà vu. Although manufactured in the 1980s, my camera was based on a design from the late nineteenth century. In fact, it was a Victorian contraption, with a history parallel to that of film.

But now, another victim of the technological advance, it had lost its widespread usefulness; no longer was it a sophisticated or cutting-edge tool. That status on this day belonged to the digital camera that sat next to it in my equipment bag. It was this digital camera (the third acquired since starting the project) that allowed me to make still photographs, record video and sound, and identify my location through a system of satellite communication, to mention only a few of its features. Like the etching press or woodblock type, my view camera had moved into the realm of the industrial curio and artist's tool.

But something else was becoming clear to me. This digital camera wasn't just another refinement of the ancient photographic machine, a camera obscura fitted with new parts to accommodate modern times. On that warm day outside Dwayne's Lab, a global shift was taking place: the noisy and chemically realized photograph that I had handled in the dark was finally giving way to a clean, numerically-formed

picture that could only be "written" and "read" by high powered calculators, often disguised as cameras and telephones. After Dwayne's finished processing the final rolls of Kodak's oldest product, there would be one fewer reason for it to be in business. In the five and a half years that I had been working on this project, the number of film users worldwide had dropped from millions to thousands; it looked more and more unlikely that the companies that had supported film would be able to survive long into the twenty-first century. The chances that they would be able to make the transition from an analog to a digital world were slight. Just as the innocuous Google server farms built to support the collective information cloud were already replacing the white windowless film factories owned by Kodak, Dwayne's would likely soon fall prey to another business, yet to be determined.

It is the impending loss of the physical and material nature of my medium that I find most disconcerting. Traditional photographs exist in the present as objects created in the past, susceptible to the imprint of time which is manifest in their physicality. They are material objects tangibly connected to the world through the nature of their creation: impressions created with silver filaments suspended in animal gelatin, altered by light and chemistry. In the digital world, images are produced with binary code and exist as information; the material magic of photography is lost. And something else may be lost, too. Photography as an art form has always been dependent for its existence on the availability of film itself, as surely as painters have depended on the availability of canvas and tubes of paint. But the availability of film has always depended in turn on demand from mass markets that have included amateurs, professionals, government agencies, the media, and the healthcare sector, to name but a few. Each of these enormous markets has switched to digital technologies because they are faster, cheaper, and more flexible. It is ironic to think that just as film has finally been freed from its mundane applications in the everyday world to be explored only as an artist's material, it could very easily disappear altogether because these market forces no longer support the industry that makes it.

The future, however, is unknown, and anachronisms cut both ways. At this juncture in history, it is difficult not to recall the oft-repeated, though apocryphal, words of the French painter, Paul Delaroche, who upon seeing a photograph for the first time in 1839, ran into the street and declared, "From today, painting is dead." Technologies are made to be transformed, and redefined, even reinvented. If this book is a eulogy for film and the miraculous process it made possible, both now consigned to the past, it is also an article of faith that anything is possible. In this present day, having captured this dark and vanishing world in what I hope is a tender light, I continue my backward march into the future.

ON ENDINGS

Alison Nordström

HISTORIANS TELL US THAT THE ADVENT OF CHEMICAL PHOTOGRAPHY WAS SUDDEN AND CELEBRATED. As soon as the process was revealed, the world recognized that the previously unimaginable ability to record a trace of the real world was utterly transformative. Photography changed everything. Perhaps no technological invention since moveable type has so profoundly affected how and what we know or remember, and how we understand ourselves. Unlike the start of this phenomenon, however, the end has come, in T. S. Eliot's words, "not with a bang but a whimper." The end of this kind of photography is the subject of this book and of Robert Burley's remarkable pictures; they chronicle both the dramatic finish of a major industrial presence and the smaller, human-scale remnants of this technology that linger in our lives and our memories.

It is important to recognize that Burley is a product of the mid-twentieth century. Born in 1957, he would have been, even before his passion for finding and making pictures was evident, an innocent participant in the photographic environment of his culture. He would have sat for fourth grade class portraits, looked at the illustrations in *Life* magazine, and wondered at snapshots of his parents taken before he was born. Like me, Burley would have known photographs as paper objects that stored images were kept on, objects with fronts and backs that generally had to be handled in order for them to be used. Like most of us, Burley would have unwittingly participated in the actions and gestures that the materiality of paper photographs would have caused to seem intuitive. He probably wrote on them, carried one in his wallet, pinned one to a wall or tucked it into the frame of a mirror, sent some, and received others in stamped hand-addressed envelopes. He may have had a shoebox of them on a closet shelf. He may even have kissed one once, or ripped one to pieces in anger. These actions are almost gone; many of them will seem alien to our children and grandchildren. These new differently made images that we persist in calling photographs interact with our bodies less. Increasingly, we view them on a screen.

Burley has set out to document a cultural shift that is, as his essay suggests, intensely personal. Its core concern is the traces that almost two hundred years of chemical photography have left on our psyches. Thus his book addresses both the products and the production of photography and the material traces both have left in the world. Not surprisingly in a eulogy to the ruins of an enormous manufacturing process, Burley's attention is drawn to the post-industrial landscape still littered with the buildings that once housed the men, women, and massive machines that produced the things we once needed to make photographs. Burley pictures them as monoliths, with only slight but revealing differences between them. The two-page spread frontispiece is the faceless white wall of Building 13 in the Kodak Canada complex in Toronto, demolished in 2007. Its very implacability and neutrality forewarns us of the book's main subject.

The overall tone of Burley's photographs may be valedictory and memorializing, but some of his most striking images are photojournalistic in nature. While much of chemical photography's disappearance has been like a slow and gradual sigh, from time to time that whimper has been subsumed by a literal and dramatic bang. Across the world, in Rochester, Toronto, and Chalon-sur-Saône, the buildings that once housed meaningful work have been coolly and purposefully destroyed, blown up or bulldozed to take them off the tax rolls. Burley's photographs not only capture the instants of explosion, but place us as viewers among the groups of witnesses that inevitably gathered at the scene. They are mature and casually dressed; many of them, Burley tells us, former workers in the buildings designated for destruction, drawn—who knows for what reason—to see the unequivocal termination of what had ended for them some time before. The circumstances of the implosion at Chalon-sur-Saône are ironic. The first blast failed; the ruined building still stood, even less useful than before.

As counterpoint to the industrial dinosaurs that Burley depicts (with a combination of irony and rueful admiration), he also introduces the smaller and more human-scale fragments of the photographic story that were once ubiquitous in our cultural landscape: The corner art photo studio with its display window of immortalized brides, graduates, and captains of industry could be almost a nineteenth-century artifact in its confident manifestation of received commercial practice, and it shows a poignantly defiant resistance to change. Burley documents the one-person darkroom of legendary photographer and photographic educator Nathan Lyons and it is similarly timeless, at least to the eyes of Burley's and my generation; it may look like a museum display to the next one. On the other hand, the matter-of-fact grid of Polaroid workers' identification photographs in Enschede asserts several worlds already gone. We are probably almost past the time when we proved who we are by showing photographs of our faces; retinal scans and DNA samples offer surer evidence. More revealing is the state of the grid itself; it is slipping and imperfect, the scraps of once-young, once-confident faces are accumulated by gravity and inattention at the bottom of the frame like a pile of fallen leaves.

The demolition of the characterless mid-century industrial building of Kodak-Pathé at Chalon-sur-Saône failed on the first try, and Burley chooses to show it as a shattered shell, the jagged holes in its side spilling fragments of walls and wires into a jumbled pile of rubble at its feet, framed by an empty parking

lot, now bereft of workers, life, and motion. The Agfa-Gevaert world headquarters turns a modest road into a timeline, from its decidedly European nineteenth-century balconied and crenellated architecture at one end to the harder, de-humanized twentieth-century buildings with windowless walls and a placeless, international style of efficiency. Oddly, it is the newer buildings that look the most abandoned. Modernism doesn't age well. It is supposed to be ever new and clean; it demands a cool effectiveness that is unchallenged by rust, water stains, and debris.

On the other hand, Burley's photograph of Kodak Tower looks precisely like what it is: an aspirational early twentieth-century building in the American Rust Belt, designed at a time when film was king and an end to such a monarchy was unimaginable. The structure's upper stories and antenna mark an effort, now abandoned, to maintain its status. Nevertheless, from Burley's vantage point it still reigns serenely over Smugtown, backed by an idealized rare-for-Rochester blue sky full of perfect fair-weather clouds. The photographs of Kodak Park are less triumphal. As in Chalon, it is the bang of implosion that embodies great change, and also as in Chalon, it is ex-Kodak workers who gather to watch buildings 65 and 69 cease to exist. Here too, they are documenting their Kodak moments (digitally, as Burley points out) with their cell phones and video cameras. A cloud of dust envelops the crowd at the moment of implosion, turning them briefly into ghosts and shadows as it settles back into the pile of rubble that was once a busy building echoing with earnest, cheerful, nasal voices. It is not easy to get inside Kodak Park to take pictures. Burley shows us only what can be seen from the street: a few isolated wooden houses loomed over by faceless factory walls, surrounded by fields and now-empty parking lots.

Burley captures Kodak Canada as a study in spare, white geometry, looking more like an architect's preliminary model than a place where people with lunch boxes came to work five days a week. Inside, Burley shows us once active rooms, abandoned in place, a boosterish slogan still on the wall, a disembodied cardigan sweater hanging in an empty administrative area, a blank green board awaiting the next big idea in an executive meeting room, a calendar on the wall, pointing to no future. Burley lives in Toronto and he has photographed the Kodak plant in his own backyard with depth and sensitivity. He shows us the vast black-painted rooms where the most light-sensitive products were manufactured; the light locks and the testing rooms; the named worker cubbies, some still holding carefully folded lab coats; and the intricate machinery for coating paper and mixing chemicals, all at the end of Photography Drive. He evokes the people who made it all matter with his literal pictures of a community dissolving. Just before Christmas, the workers had been told the plant would begin to shut down. The last day they made anything was in June 2005. They stood in the parking lot for a final commemorative group photograph, and Burley captures them just after that moment, each individual heading off alone in his or her own way.

The ruins of the Polaroid Corporation in Massachusetts look somewhat different. There is less industrial earnestness than at Kodak and more of an East Coast cerebral quality to this landscaped modernist campus, designed to look and feel like a college. Today the plantings are untended, and the buildings are bare; their interiors appear to have been hastily stripped of anything of value. The abandoned Polaroid

plant in the Netherlands is equally empty and shabby despite the valiant defiance of the Impossible Project. A mannequin, used to test skin tones, with the grid of identification pictures described above, are the closest thing to people Burley finds. At Ilford, in the U.K., Burley shows us a faded but still-familiar logo on a rusted truck, a down-at-the-heels industrial building, and some intriguing close-ups of stacked black bags of emulsion and tangled piles of unspooled roll film that suggest abstract painting. These scenes underscore Burley's contention that this last producer of traditional photographic materials will do so for artists only—large-scale industrial applications outside that niche having moved to digital as soon as it was financially advantageous.

Among other things, the photographs in this book represent several of the major genres that have been part of photography since its beginnings. Burley's images remind us of the traditions of architectural, industrial, and street photography, of still life, and photojournalism. They remind us of the still-magical way that photographs can immobilize a slice of time's continuum, preserving the precise details of something that happened in the literal blink of an eye for later perusal and contemplation. They show us too how the framing of the camera directed by the photographer's eye and vision can isolate something so ordinary that we would usually pay it no mind and imbue it with great significance. A book like this also reminds us of the ways these two-dimensional traces of real space and real time can be ordered and assembled to tell a particular story. The story is inherently nostalgic, even in the present it is about the past, but it also underscores the "this will have been" tense that Roland Barthes attributes to all photographs. Burley is recording aspects of a vanishing visual culture that are still so familiar that we may take them for granted, but it is with the knowledge that in even a few years his pictures will have become a significant historical document.

Paradigms don't change because people change their minds; they change because people die. The material things that accompany us on our journeys through the decades will often outlive us, and they are where we keep the stories we will pass down. Robert Burley has created evidence of the things we have used and valued. Some of them are vanishing before our eyes. Some will remain as genuine *aides memoires* of another time. A lot of the paper photographs will endure both in museums and in private hands. Indeed they may become more valued as they are recognized to be old, fragile, and rare, but we may forget how to look at them as they were once looked at. We will keep the technologies that can be practiced on a human scale for a niche market, and artists and craftsman can add gelatin silver printing to the anachronistic tool chest that already contains daguerreotype, collodion, cyanotype, and platinum. Some of the buildings, I suppose, will be recycled, reabsorbed into the culture of the future in a manner that will obscure their roots and first purposes. Perhaps these photographs and their technologies will persist longest in our language and in its unnecessary skeuomorphic references to passé practices. The pictures on my mobile phone, I notice, are organized by roll; the phone makes the noise of a shutter and opens and closes one with a digital graphic when I press the camera-shaped icon. We still hold our hands in front of our eyes and press an imaginary button when we wish to signal taking a picture, though the actual physical gesture

has changed to looking at a screen held at arm's length in front of us or above our heads. It's not much to show for more than one hundred years of pervasive industrial production that employed millions, gave joy and memory to many more, showed us places we had never been, and shaped a century like no other invention.

It is hard not to think of Shelley's Ozymandias, the once all-powerful Egyptian ruler reduced to a broken statue in an empty desert with a hollow inscription once undeniable but later ironic:

> "My name is Ozymandias, King of Kings:
> Look on my works, ye mighty, and despair!"
> Nothing beside remains. Round the decay
> Of that colossal wreck, boundless and bare,
> The lone and level sands stretch far away.

Yet it is exactly pictures like Burley's that guard the photography-that-was against sinking into the desert sands of time. It doesn't really matter how he made them—that they were shot on film—though there is a certain poetic justice in this that we appreciate. We may regret the loss of materiality in the way we see and know images like these but we have them. We can hold this book in our hands and turn the pages for our children and grandchildren and tell them what we remember of a different time from theirs.

ALISON NORDSTRÖM IS SENIOR CURATOR OF PHOTOGRAPHS, GEORGE EASTMAN HOUSE INTERNATIONAL MUSEUM OF PHOTOGRAPHY AND FILM, ROCHESTER

IT TAKES MORE THAN ONE BLAST TO BRING DOWN A FACTORY

François Cheval

It used to be, driving by the Kodak-Pathé plant in Chalon-sur-Saône, you knew exactly what you were looking at. Giant cubes topped with the company name spoke of size and solidity, of the unrivalled power and success of an enormously prosperous company. If film ever found its true expression as architecture, this was certainly it: a blend of silo, bunker, and refinery allied to the minimal elegance of industrial modernity.

But this maze of white buildings was not the sort of place you just wandered into. Stamped with its own capital letter, each building stood for an entity, a moment in photographic history: emulsion, paper, etc. These were otherwise familiar things backed up by organic chemistry. It was clear, more or less, *what* was made there, but to see *how*, it was necessary to show ID at a checkpoint, explain your business, and then swap your papers for a badge. The chemicals industry loves secrecy—especially Kodak.

In 1885, amid a deluge of advertising, the Eastman Company of Rochester, New York, launched its patented transparent film, based on the first mass-production method of photosensitization. Flexible celluloid film was the single most profitable item ever sold on the photography market. Patents were enormously important to George Eastman: he tirelessly applied for, purchased, and, when necessary, used legal finagling to filch them. Like other captains of industry, he felt an insatiable need to vie with his competitors, and tried to wrest their patents and know-how from them by all possible means. The simplest way was often to buy out the competition, a characteristic Kodak strategy.[1]

Eastman's patents formed the foundation of the company; they were the legal enshrinement of its technical innovation. This is evident in the design of Kodak cameras, where optics, chemistry, and mechanics met in a highly specific object that combined cheapness with simplicity of use. Fun and the notion of total control at every point in the operation determined the camera's overall value, but effective possession

of the entire range of relevant patents—the keys to control—guaranteed exclusive rights to the product and independence of production for the brand owner.

It took years to build up the sheaf of patents. The snapshot and the mass marketing of the image drew on an unshakeable belief in the needs of the future, but implementation of the project could hardly have been an easy matter. The race for patents kept the industry on permanent war footing; and Eastman, like an alchemist with his alembic, spared no effort in his determination to corner the market by combining patents with ongoing innovation. Between 1895 and 1909, buyouts and mergers saw Eastman consolidate his position within the American industry and maintain his dominance within the amateur photography market he had created.

Eastman had built his empire by reducing a complex, professional process to a simple series of actions anyone could perform. Photography had prospered under his reign. From the first dry plates to the Box Brownie, from the Instamatic to the point-and-shoot, the company's history is also the biography of a man who knew how to choose talented, scientifically trained staff. Eastman might have been a self-made man, but he had no hesitation about assembling an elite team, hiring graduates of the nation's top technology institutions. Darragh de Lancey and Frank W. Lovejoy, from MIT; Perley Smith Wilcox from Cornell University; and Frank A. Brownell—"the greatest camera designer that ever lived"—strove endlessly to perfect the cameras, speed up production, and simplify utilization in a constant quest for cost reduction and market penetration.

These members of the company's old guard protected it from routine and fossilization. They were the men who led the concern from its early pragmatism to planned and quantified mass production. By the late nineteenth century they had revolutionized the production of film and turned Kodak Park into the most modern plant of its kind in the world. George Eastman had himself become a monument.

On January 19, 2012, Reuters announced that Kodak was filing for bankruptcy protection: "The bankruptcy procedure and the credit line are intended to give the group time to find buyers for its 1,100-odd digital patents, while enabling it to continue paying its 17,000 employees," stated CEO Antonio Perez. He added, "We are taking this step at this point in our transformation so we can bolster liquidity and monetize non-strategic intellectual property." In terms of the company's recent history, though, this announcement was part of a slow, relentlessly logical descent into hell. Kodak took out its first digital patents in 1975, but starting in the 1990s, failure followed failure: the Photo CD system, Advanced Photo System (APS) film and, in an unbelievable turnaround, the lack of cameras capable of meeting the competition from Japan. Since 2003 the company has systematically closed and demolished thirteen plants and 130 laboratories, with layoff after layoff leaving whole towns drained of their life-blood.[2] Now the Eastman empire is worthless.[3]

In 2005 a confidential internal document, "Transformation and the Path to Reestablishment," proposed a way out of the crisis: "The traditional-to-digital transition is happening even faster than we thought. The result is that we need an even more streamlined organization built on the digital (rather than on the traditional), with fewer staff and greater, exceptional skills." Unfortunately this summary came

much too late for a company with its back to the wall. The company put itself in the hands of the managers and financiers, and this, combined with neglect of its technical staff, meant that the Kodak *raison d'être*—photography for all—was forgotten.[4] Ironically, some of the decision-makers thought they could get the company out of trouble by selling off thousands of patents.

One by one the factories came down. A whole world had come to an end: Colorama, Kodachrome, dye-transfer, and TRI-X films were destined for the photography museums which—like the one in Chalon-sur-Saône—Kodak-Pathé had haughtily ignored.

Kodak took enormous care of a corporate image shaped by all kinds of scientific specialists. In France the merger between Pathé-Cinéma and Eastman Kodak in 1927 confirmed this state of affairs.[5] Kodak-Pathé too went to the top schools for its recruits and more than once these specialists became CEOs: among them were Alfred Landucci[6] and Lucien Vacher, both graduates of the City of Paris Advanced School of Chemistry and Physics and both originally with Pathé. Originally from the provinces, one lean and reserved and the other tubby and talkative, they knew all there was to know about making film and shared the same ambitions for Kodak-Pathé. With their arrival on the highly competitive mass consumption scene, it was obvious that their dedication to the firm would provide an invaluable contribution to the transition from one mode of production to another. Their attitude, character, and strategy—everything about them, in fact—signalled the self-confidence born of habitual success in business.[7]

The chemical industry had always been an insatiable consumer of space, concrete, and steel. The Rochester plant had been through its time of shortage, and with the merger, the French subsidiary was facing its own real estate problems. Sites in Vincennes and Sevran had to meet the demands of a constantly expanding market, which meant modernizing the machinery in the cooling plant, the heating plant, and the electrical plant. And despite the lack of space, there had to be storage facilities for raw materials and finished products. Most importantly of all, there had to be room for making space-hungry emulsion.

Eventually it became clear that if the situation was to be dealt with, further on-site expansion was out of the question. So the search for fresh locations began. The Pathé plant in Vincennes dated from 1907, and although it had fulfilled its task for over thirty years, everything hinged on the ability of the technical departments to make the most of the available space. In the heart of town, the plant handled the manufacture of film and emulsion, the application of the emulsion to the film, and the finishing-off. In the 1950s, the Sevran plant built by Eastman Kodak France was in charge of processing photographic products (namely Kodachrome). Residential areas surrounded both plants, and because they were rightly considered health hazards, they were subjected to strict official surveillance.

No longer capable of meeting the demand from a rapidly expanding European market, and faced with the impossibility of any kind of extension, the company had no choice but to think in terms of another plant. And so the search for a new location began in 1952.

The site chosen was Chalon-sur-Saône, north of Lyon. However, the decision by Eastman Kodak to set up in the hometown of Nicéphore Niépce was an economic one, involving no homage to the inventor

of photoengraving.[8] As a direct consequence of France's town planning policy of the 1950s, the Kodak board opted for the gradual relocation of the Vincennes plant into the provinces in 1956, with an initial acquisition of thirty-five hectares toward the end of the same year.

The company was delighted with Chalon-sur-Saône, which earned the board's approval because of its waterways—the river Saône and a canal—and its position in the railway network.[9] These factors meant a quick, reliable supply of raw materials such as paper and gelatin, which came mostly from the southeast. Its geographical situation, just when France's first freeways were being built, put it at the heart of a transport system that matched company needs perfectly. From here Kodak-Pathé could liaise with the center of France via road and water, with the entire national rail network, and almost directly with the Mediterranean.[10] These assets—plus the fact that local workers had a good reputation and the municipal council wasn't one for making waves—led to the site being chosen over other contenders elsewhere.[11]

The first building went into operation in 1961, housing the assembly lines for the packaging of chemicals and the sensitization of film. Nothing on a large scale, yet, but the date was an important one. Other workshops went into service one after another, while the plant at Vincennes gradually emptied. As time went by the Chalon site was upgraded from simple workshops—Film Reel Finishing, for example—to more complex functions such as film production. Thus it became a true factory, with an increase from 42,000 square meters (at Vincennes) to 750,000 square meters, and a productivity that accompanied the company's success until decline set in the 1990s.[12] One high point came when the plant supplied all of Europe with GOLD II color negative film for the Winter Olympics in Albertville in 1992.

It was very cold on that gray day of December 9, 2007. Every major figure from the city and from miles around was there for the demolition of the main building. The board of directors had set up a tent so its guests could sip their champagne out of the wind and rain. The executives were proudly wearing caps bearing the company logo. There were other people who had come along for the show, too: long-time workers at a factory that had once employed 3,000 people. Dismayed and rigid with cold, they did not dare move for fear of missing out on things or suffering a nervous collapse. Suddenly, after a long wait, the countdown started. And nothing happened. The demolition had not worked.[13]

So after a few sarcastic jokes about the dynamiting team brought in specially from the United States, everyone went home feeling no grimmer than the day before, but still just as reflective. These people had not just been witnesses to all this ongoing innovation in the world of the image; they had played a real part in the incredible transformations of Nicéphore Niépce's original invention, and now they no longer knew where they belonged. It seemed to them that the world they lived in had become a strange place, one going its way without them.

1 Between 1890 and 1894 Eastman took over twenty-seven companies.

2 In 1964 Eastman-Kodak had twenty-eight plants around the world, with ten in the United States alone. There were 250 treatment and research laboratories, and the group as a whole employed some 75,000 people in fields that had been extended to include chemicals: in 1967 fully one third of the company's business was non-photographic. In the same year, Kodak-Pathé in France employed 8,500 people.

3 In October 2011 Kodak shares collapsed, losing 50% of their value in a single day on Wall Street.

4 The decline in influence of the design staff dates from the 1970s. Paul Vuillaume was put in charge of Kodak-Pathé in 1971. A graduate of France's prestigious EHESS (School for Advanced Studies in the Social Sciences) he had, nonetheless, begun his career at the Kodak plant in Vincennes, near Paris, in 1942.

5 The Eastman Photographic Material Company, an English company, set up its Paris branch in 1891 on Rue des Apennins, in the 17th arrondissement.

6 CEO at Kodak-Pathé from 1952 to 1962. He was succeeded by Lucien Vacher.

7 "It was a fine marriage: initially one of reason, it quickly became one of love, which is a wonderful thing."—Alfred Landucci.

8 Close examination of the group's magazines and periodicals from 1949 up to the opening of the new site reveals only a single reference, by Landucci, to the invention of photography: "By a curious coincidence our third factory will be situated not far from the birthplace of Nicéphore Niépce, the inventor of photography. So it is starting out under good auspices." ("Monsieur Landucci talks about the new plant," Kodeko, December 1956.) There is another, brief reference to Niépce in an article on the history of Chalon-sur-Saône in June 1962: "In 1822 Nicéphore Niépce, the most eminent of Chalon's sons, invented photography at Saint-Loup-de-Varennes."

9 "Monsieur Landucci talks about the new plant," Kodeko, December 1956.

10 "After a survey of the entire country, and a scientific assessment of the appeal and the industrial potential of the Moselle and Bouches-du-Rhône départements, Chalon was the definitive choice." ("New Plant in Chalon-sur-Saône," Kodeko, March–April 1970).

11 "Chalon has a well-established reputation as a welcoming city, with its residents agreeable and its way of life unaffected by the increasing speed of the big metropolises. All in all this is a city on a human scale, which probably explains the fondness of newcomers for their adoptive home." ("The Economic Expansion of Chalon-sur-Saône," Kodeko, February 1970.)

12 In 1992 Kodak-Pathé sales were 7.8 billion francs (or about 1.57 billion dollars). The Chalon plant's output comprised medical and industrial x-rays (32%), film and paper (39%), chemicals and miscellaneous (15%), and professional movie-making (14%). Kodak-Pathé Annual Report (1992).

13 After the December 9th fiasco, the dynamiting took place, furtively and ingloriously, two months later in February 2008.

FRANÇOIS CHEVAL IS CHIEF CURATOR, MUSÉE NICÉPHORE NIÉPCE, CHALON-SUR-SAÔNE

[TRANSLATED FROM THE FRENCH BY SONIA FLORIANT]

ART AND COMMERCE, CREATIVITY AND INDUSTRY

Andrea Kunard

THE SHIFT TO DIGITAL TECHNOLOGY AND THE SUBSEQUENT COLLAPSE OF KODAK AND POLAROID have caused barely a stir in the art-photography world. This is not surprising; artists and museum professionals rarely acknowledge the industries that support art production. Yet, the dramatic changes in the photography industry underscore a need to explore how photography has participated in, and shaped, consumer culture. Robert Burley's latest body of work, *The Disappearance of Darkness*, is a vital contribution to a subject that has drawn little commentary thus far, providing opportunities to explore the social and cultural reverberations of the industry's changing fortunes, and to appreciate the interrelation of art, commerce, creativity, and industry.

Since the 1990s, some writers have argued that technologies are subject to and express cultural biases and values.[1] They do not develop ahistorically, subject to their own autonomous rules, but are affected by global economic inequities and social inequalities that determine how they are used and absorbed into society.

Cultural theorist Martin Lister notes that the digital production, circulation, and consumption of photographs do not impact on previous technologies in a singular and monolithic manner.[2] Michelle Henning agrees, stating in her writings on obsolescence that the relation between new and old technologies is complex and sometimes contradictory. She argues that although the new is always changing, obsolescence often lags, with new and older forms of technologies coexisting simultaneously.[3] Market forces have selected certain continuities from analog to digital photography. Familiar forms of camera bodies and lenses helped ease consumers into purchasing a product advertised as superior. Digital pictures can be viewed immediately, downloaded, and easily sent to friends and family, but are they inherently better? Henning notes that in a sense, analog photography "had to be made obsolete, and its obsolescence had to be presented as inevitable."[4] Such processes are linked to Raymond Williams's observation of culture as a

dynamic process. Old and obsolete do not simply disappear; they linger at the margins or resurface expressing different values.[5] They may become associated with nostalgia, develop into retro fashion statements, or acquire oppositional worth as a way to promote the new as exclusively new.

Since the 1970s, critics have argued that a photograph's value and meaning depends on its context of generation and reception. In an image-generating culture, meanings, references, and resemblances overlap, proliferate, and transform, creating new contexts and meanings. The process of isolating and rarifying the photograph as art within the art museum has prevented, with some exceptions, discussion of relationships between art photography and its industrial base. Peter Buse examines the silence surrounding the art photograph and its inherently commercial characteristics.[6] He argues that the relation between photography, art, and commerce is complex, and in Polaroid's case, mutually enriching. However, the relationship was never openly celebrated. Curators such as Peter Bunnell dismissed the Polaroid as a true creative medium, relegating it to the amateur photographer. Nonetheless, photographs by Ansel Adams appeared in Polaroid advertisements, and Adams included Polaroid photographs in *Aperture* magazine. For its part, the company capitalized on its links with the artistic community, emphasizing the creative possibilities of the Polaroid print, going so far as to fund various art groups and initiate programs, such as the Artist Support Program.

The disruptions generated by the digital transition echo those of the late nineteenth century, when a relatively stable commercial photography industry was severely challenged by the introduction of the handheld camera. Like many industries of that era, photography was strongly tied to the reorganization of finance and capital that allowed continuous production of goods and ease of transport to points of consumption. Yet as much as photography participated in the burgeoning material economy, commercial success was not automatically assured. Within a constantly changing social and economic environment, photographers invoked art to validate the business of photography.[7] Public demand for imagery had produced a large and viable market, but writers in the period's photography journals expressed concern at the general public's boredom with standard products. They argued that photographers had to maintain a standard of quality and introduce novelty to ensure continued business.

From the beginning, the photographic industry quickly adapted to keep photography affordable: labor was segmented, a continuous market created, and products were standardized. The final product was not necessarily an individual expression; often it was a synthesis of numerous employees' labor, sold under the name of the studio owner, who may not have been a photographer.[8] For a studio, success depended on a robust clientele, which meant patrons had to be photographed quickly and efficiently. To expedite this process, the studio established stock sets and props; these articles also served as signatures of a particular studio. As a result, many studio photographs from this time-period are similar in terms of pose, lighting, and decor.

Such standardization allowed photography to flourish, but it also created problems. The business of photography required a market to buy the product. Economic depression, then as now, affected the

middle and lower strata of society, the principle consumers of photography.[9] Carefully balancing consumer interest with affordability assured repeat business. Photographers combated a bored market by introducing new, specialized products. They advertised the novelty of their latest studio props and scenic landscapes to entice customers back to the studio. Other proprietors attracted patrons with celebrity portraits of political figures, artists, actors, and writers, ordered through catalogues and distribution warehouses.

While magazines promoted photography as a serious endeavour, they also had to quash any lingering doubts about photographers' abilities to produce a reliable product. Although some studio photographers produced fine examples of portraiture, the business was far from homogenous. Between 1851 and 1900, many Ontario photographers are listed as combining photography with other livelihoods: oyster vendor, druggist, bookseller, stationer, watchmaker, dentist, and saloon operator.[10] Numerous—often-untalented photographers—flooded the market, threatening industry standards with inferior photographs and slip-shod techniques.[11] Given these conditions, artistry and craft became signs of quality and professionalism. Art became associated with "progress," a watchword of the period. As one writer noted, success in business was linked to public expectation in the principles of art as applied to photography.[12]

By the late 1850s, business was waning. The introduction of the *carte-de-visite* captured the public imagination, and the industry responded in kind. Around 1866, writers began to promote the cabinet card over the *carte-de-visite*. They argued its larger size provided a better format for portraiture.[13] As these examples indicate, the industry repeatedly adapted to changing economic conditions and consumer demand. With the introduction of the dry plate and handheld camera, the industry again experienced challenges. The increased accessibility of the camera to the general public resulted in the collapse of many commercial studios and seriously threatened the livelihood of many others.

Yet, these very industrial changes impacted aesthetic concerns. Sarah Greenough's seminal study on the photography of this uncertain period describes how Kodak threatened the perception of the photographer as a singular profession.[14] With the handheld camera, individuals could create their own photographs independent of commercial studios. To the horror of commercial photographers, amateurs were happily filling their albums with poorly composed prints of children, pets, and vacations. However, this transformation in the market also created an opportunity to nurture a niche clientele of serious amateurs who sought higher technical and aesthetic standards in their images. Their demands, in turn, returned credibility to the industry as a whole, forcing the commercial photographer to maintain high standards against which creative amateurs could measure their accomplishments. The polished professional could charge higher prices for their work, be a guide to camera enthusiasts, and sell them the latest equipment and supplies with authority. Consequently, the massive change in the photography industry resulted in a more concentrated effort to define an art of photography, known as pictorialism.

Although many photographers (Alfred Stieglitz among them) rejected pictorialism, that work, supported by a vast network of camera clubs, helped to ensure the medium's popularity. Christian Peterson, who has written extensively on pictorialism, notes that many camera club members and commercial photographers

created photographs based on modernist visual strategies favouring "simplicity, idealization and rampant optimism."[15] As a result of increased opportunities for display (whether through these clubs or advertising), the public became more sensitive to visually sophisticated imagery, and greater aesthetic awareness led to greater demand for creativity. As Peterson also explains, the photography industry began to take advantage of the art market by directly referencing salon activities in their advertising. Leading pictorialists, in turn, allowed manufacturers to use their names and imagery to sell their products.[16]

Historically, photographers and the photography industry have had almost exclusive, mutually beneficial relationships. With the move to digital, key aspects of this relationship changed: the usurpation of the darkroom by Adobe Photoshop, for one. As writer Are Flagan notes, while Photoshop's widespread adoption is impressive, the program broke links to traditional imaging processes in critical ways.[17] Although earlier versions were based on the plastic arts such as drawing and painting, the introduction of layers emphasized algorithms and merging of complex data structures.[18] Increasingly, Adobe software engineers privileged processing information over creating prints. Application utilities combined not only previous photographic traditions, but also web programming. On the Internet, the materiality of a photograph dissolves; the urge to touch is replaced by the hand-shaped cursor passing over hyperlinks. "Where the ensuing journey [of photography] once transpired in a set time and place," writes Flagan, "it now unfolds and collapses indefinitely through information architectures that are powered by computational algorithms and only intermittently substantiated by pixel values."[19]

To understand the image as intangible information, as opposed to material object, underscores the duality of presence and absence that informs much of photography. The photograph's materiality is understood to retain a trace of something lapsed. These properties are accentuated by its physicality, something that can be held and preserved as keepsake. The disappearance of the analog photograph and its production facilities thus echo anxieties inherent in the medium. Yet, even though reality is increasingly reconfigured into code, what appears and has presence as image can still be felt as absence. Moreover, analog photography is able to retain distinctiveness within imaging technologies, most often as nostalgia for older reflective ways of image viewing.[20] Other authors have extended these ideas to argue that in an internet culture, photographs have less value as objects than they do as experiences. Robin Kelsey and Blake Stimson write, "Trust in photography, once vested in indexicality, must now be lodged in its ability to facilitate social commitments that recognize the traffic between the burgeoning image world and the social and political realities in which it is materialized."[21]

Throughout its history, the photograph has signified values within consumer-driven economies. Recent changes continue the process whereby the medium is reinvented yet again through diverse channels of signification. What is of interest are future characterizations of the medium and how these substantiate the value and worth of photography for society.

1 Such as Sadie Plant, Rosi Braidotti, and Donna Haraway.

2 Martin Lister, "Introductory Essay," in *The Photographic Image in Digital Culture* (New York: Routledge, 1995), 7.

3 Michele Henning, "New Lamps for Old: Photography, Obsolescence and Social Change," *Residual Media*, ed. Charles Acland (Minneapolis: Minnesota University Press, 2007), 48–65.

4 Ibid., 53.

5 Ibid.

6 Peter Buse, "Polaroid, Aperture and Ansel Adams: Rethinking the Industry-Aesthetics Divide," *History of Photography*, vol. 33, no. 4 (November 2009), 354–69.

7 See Elizabeth Anne McCauley, *Industrial Madness: Commercial Photography in Paris, 1848–1871* (New Haven: Yale University Press, 1994) for case studies on particular studios.

8 Ibid., 7.

9 "Enterprise in Photography," *The Philadelphia Photographer* 12:138 (June 1875), 161–62.

10 Glen C. Phillips, ed., *The Ontario Photographers List* (Sarnia, ON: Iron Gate Publishing Co., 1990).

11 "Commercial Photography," *British Journal of Photography* 14:352 (February 1, 1867), 47–48.

12 J. Perry Elliott, "Our Profession: What Is It?" *British Journal of Photography* 19:625 (April 26, 1872), 197.

13 "Cabinet Portraiture," *The Philadelphia Photographer* 4:44 (August 1867), 247.

14 Sarah Greenough, "'Of Charming Glens, Graceful Glades, and Frowning Cliffs': The Economic Incentives, Social Inducements, and Aesthetic Issues of American Pictorial Photography, 1880–1902," *Photography in Nineteenth-Century America*, ed. Martha Sandweiss (Fort Worth and New York: Amon Carter Museum and Harry N. Abrams, 1991), 258–81.

15 Christian Peterson, "Harry K. Shigeta of Chicago," *History of Photography*, vol. 22, no. 2 (Summer 1998), 189.

16 Christian Peterson, *After the Photo-Secession: American Pictorial Photography, 1910–1955* (New York: W. W. Norton & Company, 1997), 79.

17 Are Flagan, "Layers: Looking at Photography and Photoshop," *Afterimage* 30:1 (August 2002), 10–12.

18 Ibid., 11.

19 Ibid.

20 Martin Lister, "Photography, Presence, and Pattern," *Photography Theory*, ed. James Elkins (New York: Routledge, 2006), 356.

21 Robin Kelsey and Blake Stimson, "Introduction," *The Meaning of Photography*, eds. Robin Kelsey and Blake Stimson (Williamstown, MA: Sterling and Francine Clark Institute and New Haven: Yale University Press, 2008), xxiv.

ANDREA KUNARD IS ASSOCIATE CURATOR OF PHOTOGRAPHS, NATIONAL GALLERY OF CANADA, OTTAWA

THE END OF FILM

Throughout the twentieth century, professional photographers were those with the specialized knowledge and equipment required to create artful photographic images that were above and beyond the ability of any amateur. Theirs was a respected trade that combined knowledge of both technology and art, and their services were in constant demand. Ironically, while most professional photographers spent years learning their craft, they knew little about how their materials were made, and were dependent on a photographic industry over which they had no control. Just as the skill involved in making photographs retained an aura of mystery and magic, the production of films and papers remained a closely guarded secret held by a few profit-driven corporations.

With the decline of traditional photographic methods, the commercial photographic studio, a mainstay in every town around the world, began to fade into history. The Art Photo Studio, established in 1951, stayed in business for over fifty years; it was converted into an upscale pâtisserie in 2008.

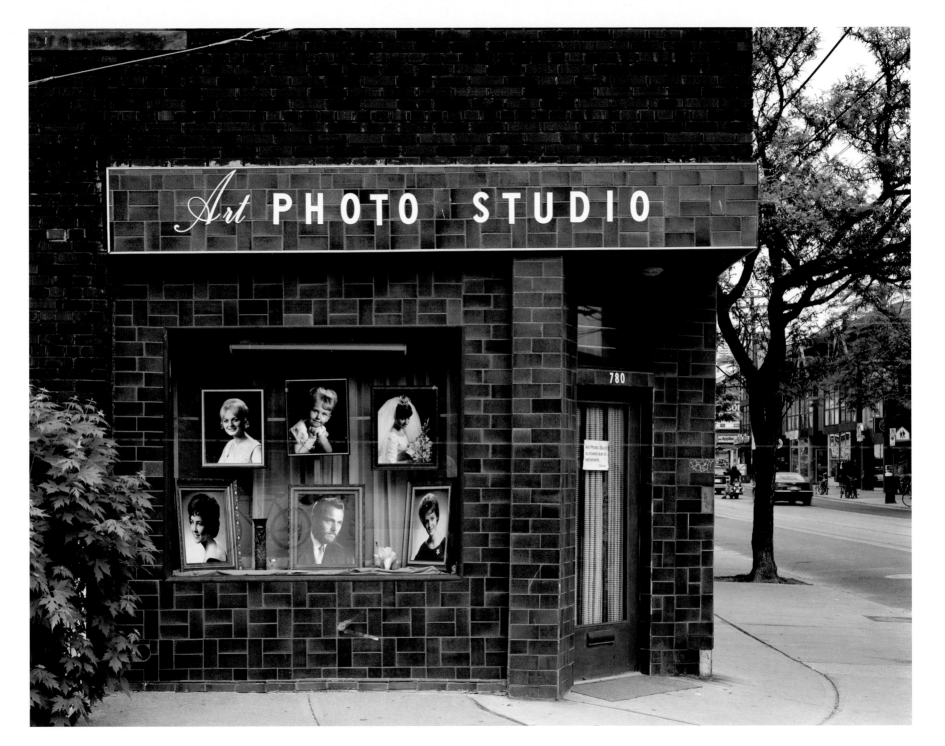

ART PHOTO STUDIO: CLOSED DUE TO RETIREMENT, TORONTO, ONTARIO 2005

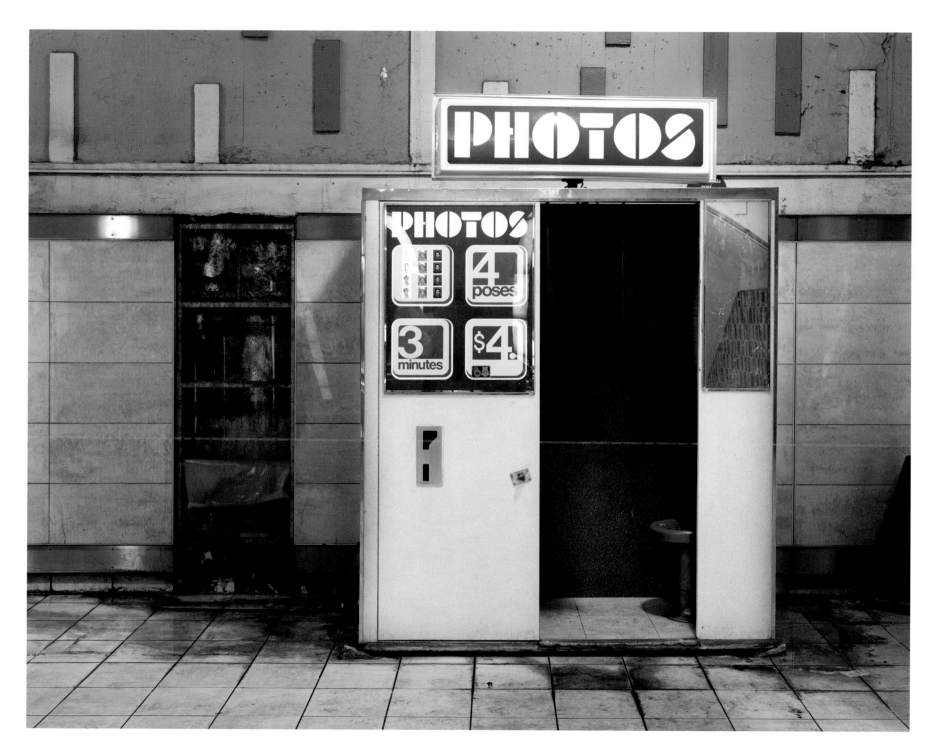

PHOTO BOOTH, METRO STATION, MONTREAL, QUEBEC 2010

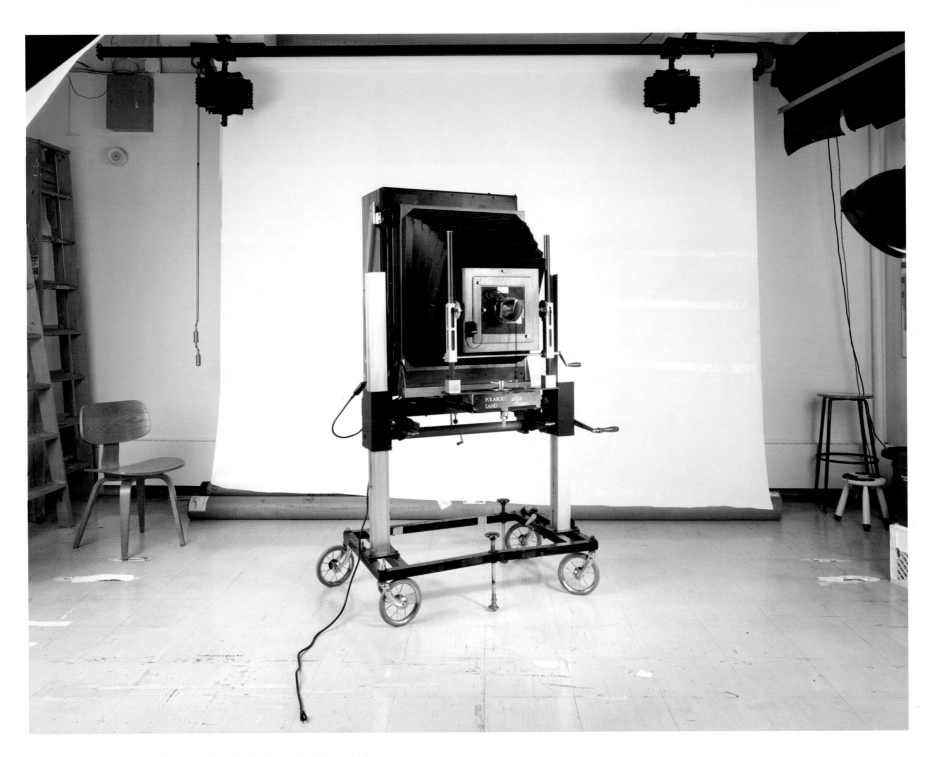

ELSA DORFMAN'S POLAROID CAMERA, CAMBRIDGE, MASSACHUSETTS 2009

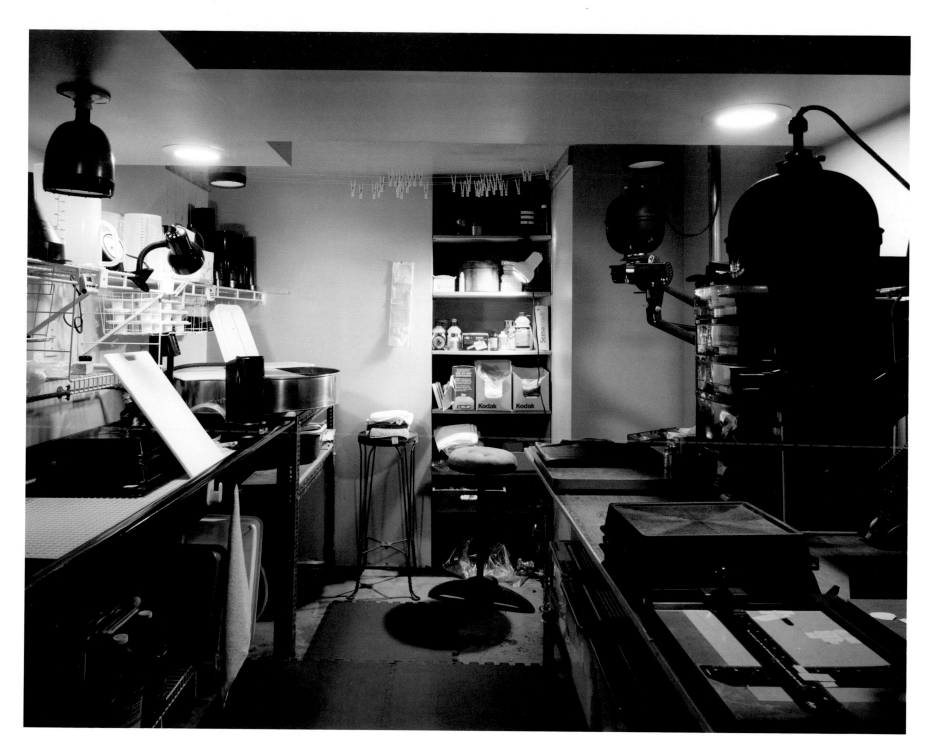

NATHAN LYONS'S DARKROOM, ROCHESTER, NEW YORK 2009

Much of photography's early history took place in villages and small urban centers off the beaten track, so it was not surprising that the end of the medium's longest running product, Kodachrome film, would play itself out in Parsons, Kansas, a small town in the American Midwest—a three-hour drive from the closest international airport. A family-run business, Dwayne's was the last photography lab in the world to process the iconic transparency film that had defined the standard for color photography. Invented by two classical musicians, Leopold Godowsky Jr. and Leopold Mannes, Kodachrome was first introduced by Kodak in 1935 as a movie film, but soon became indispensable for still photographers who sought to record their world in color. Over the course of its seventy-five-year life, Kodachrome became a part of popular culture: figuring in the music of Paul Simon, in the name of a national park in Utah, and in the countless color photographs that appeared on the covers of every major magazine, shot by some of the world's most renowned photographers.

Unlike other color films, Kodachrome required specialized equipment and processing chemistry, that was discontinued by Kodak in 2009. One year later, on an unseasonably warm day at the end of December, Dwayne's accepted Kodachrome for processing for the last time, with a cut-off time of noon. Film arrived from around the world by mail, courier, and in person, while overwhelmed lab employees struggled to keep up with the high volume. Concerned that they might not have enough chemistry to process the thousands of rolls that came in that day, the lab manager called the Kodak Company to assist with calculations in relation to their remaining stock. He quickly discovered that the lab was short of one crucial chemical component: the magenta dye. Kodak was able to find the last available container of this dye—one that had been used in the research labs—and shipped it to Parsons. The last rolls of film received that day were run through the Kodachrome processor at 1:30 p.m. on Tuesday, January 19, 2011.

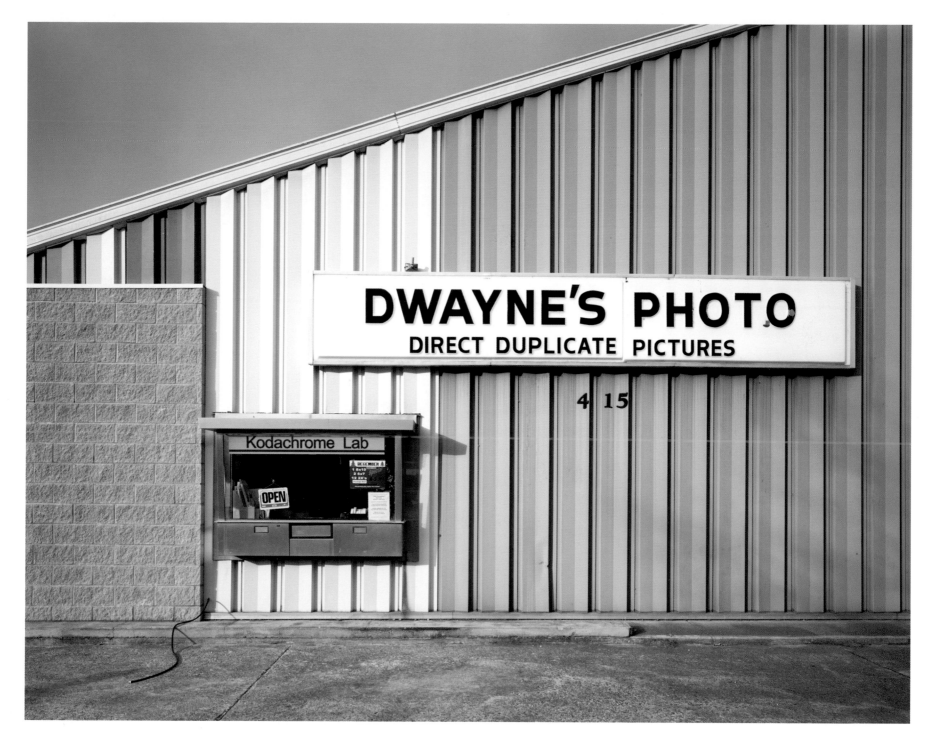

DWAYNE'S PHOTO LAB, PARSONS, KANSAS DECEMBER 30, 2010

It's curious that the industry responsible for creating sci-fi visions of the future in films such as *Metropolis* (1927), *2001: A Space Odyssey* (1968), and *Blade Runner* (1982) would be the last mass market to use film. Then again, Hollywood has always been a world steeped in nostalgia. One of its staples is the period film that takes us back to the past, which begs the question: can cinema carry on without those heavy reels of celluloid that have generated make-believe worlds inside dark and crowded rooms for the past century? It can, but without film and its telltale dust, grain, scratches, and visual markers that have historically shaped the movie-going experience. Gone, too, is sound film, with its optical track photographically imprinted into the celluloid next to the image, and the sound of it whirring through a projector at 24 frames per second.

When, in 2008, the Academy of Motion Picture Arts and Sciences awarded a "Best Picture" Oscar to the film, *Slumdog Millionaire*, it marked the first time in history that this award went to a production shot (mostly) digitally. In 2011, the last professional motion picture cameras rolled off production lines; companies such as Arriflex and Panavision had decided to focus on manufacturing exclusively digital systems. That same year, the number of movie theaters in North America that had switched from film to digital projectors passed the 50 percent mark. Industry insiders predict this transition will be complete by 2013.

In 2011 motion picture film accounted for over 90 percent of all of Kodak's film sales. Once Hollywood, Bollywood, and Pinewood—the former owner of Toronto Film Studios—no longer need film, the medium may disappear entirely.

FORMER TORONTO FILM STUDIOS, PROPOSED SITE OF NEW WAL-MART, TORONTO, ONTARIO 2011

Chalon-sur-Saône, located south of Dijon in Burgundy, France, played an important role in the history of photography: it was here in 1827, that inventor Joseph Nicéphore Niépce created the first surviving photograph. Tourists can still visit the third-floor laboratory in the nearby village of Saint-Loup-de-Varennes, where Niépce successfully fixed the image of his camera obscura onto a pewter plate, using chemicals mixed with bitumen of Judea.

It was only fitting that Kodak would establish a manufacturing facility in Chalon, the city that claimed to have invented photography. They did so in 1961, by which time Niépce's invention had grown into a global phenomenon. The plant seen on the facing page, operated by Kodak-Pathé, produced a variety of film products for nearly fifty years. When Kodak announced the facility would be closed in 2006, it was a shock not just to the city's economy, but its citizens as well. On a gray December morning in 2007, crowds gathered to watch the death of photography in its birthplace. Photography refused to go quietly. After the demolition team had set off the 950 kilograms of explosives placed at the base of the building, only a portion of the structure came down. An embarrassed group of Kodak executives were forced to schedule a second attempt in February of 2008, which successfully ended the company's presence in Niépce's city.

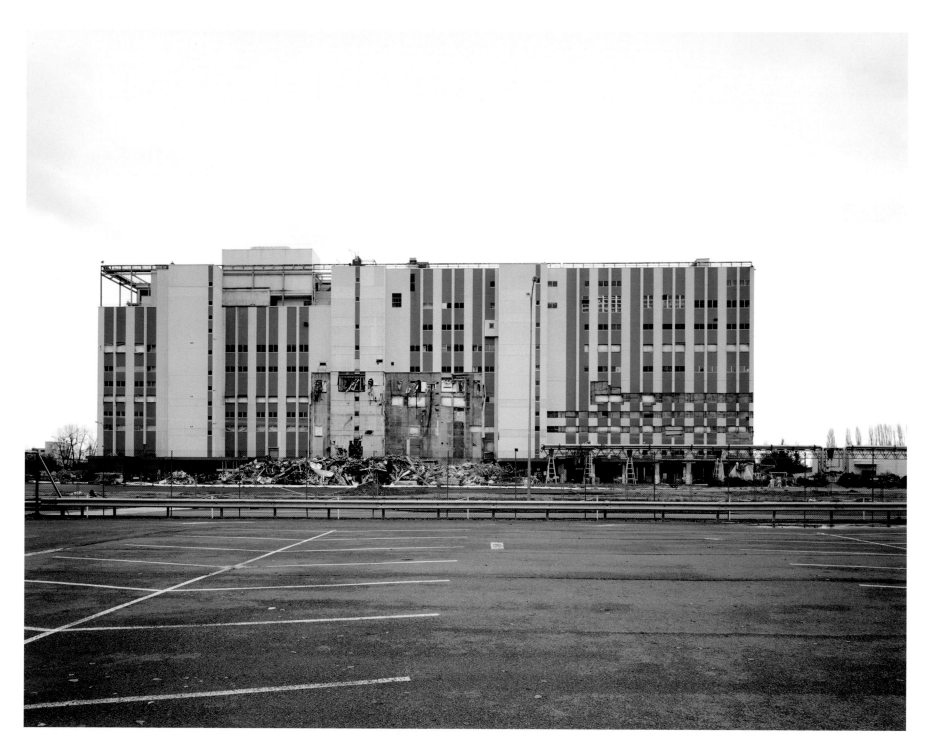

BEFORE THE IMPLOSION OF THE KODAK-PATHÉ BUILDING GL, CHALON-SUR-SAÔNE, FRANCE DECEMBER 8, 2007

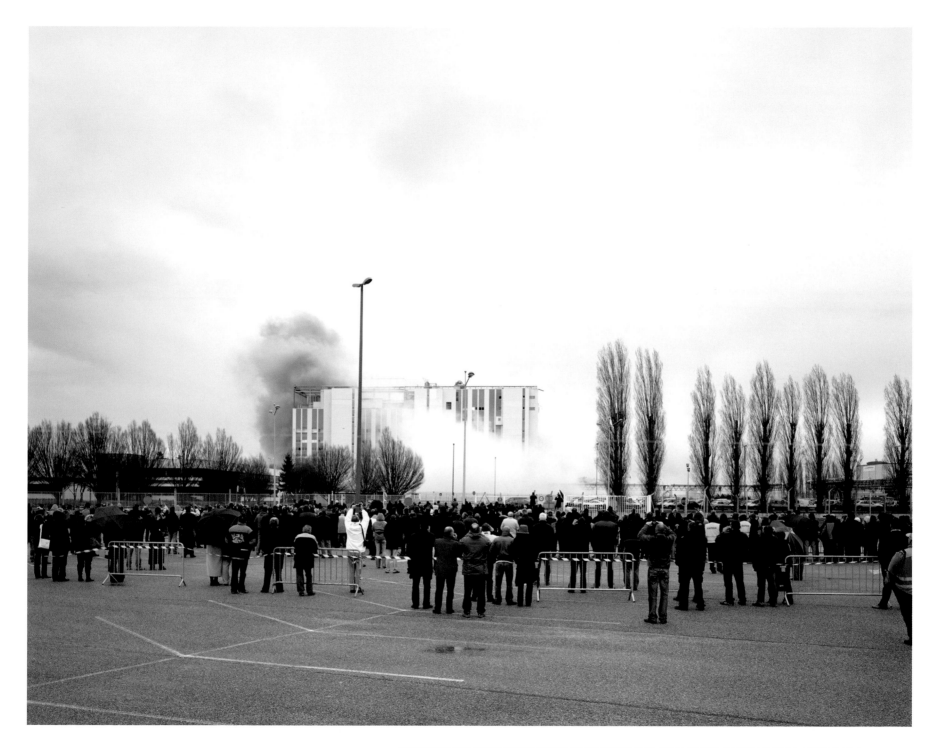

ATTEMPTED IMPLOSION OF THE KODAK-PATHÉ BUILDING GL, CHALON-SUR-SAÔNE, FRANCE DECEMBER 9, 2007

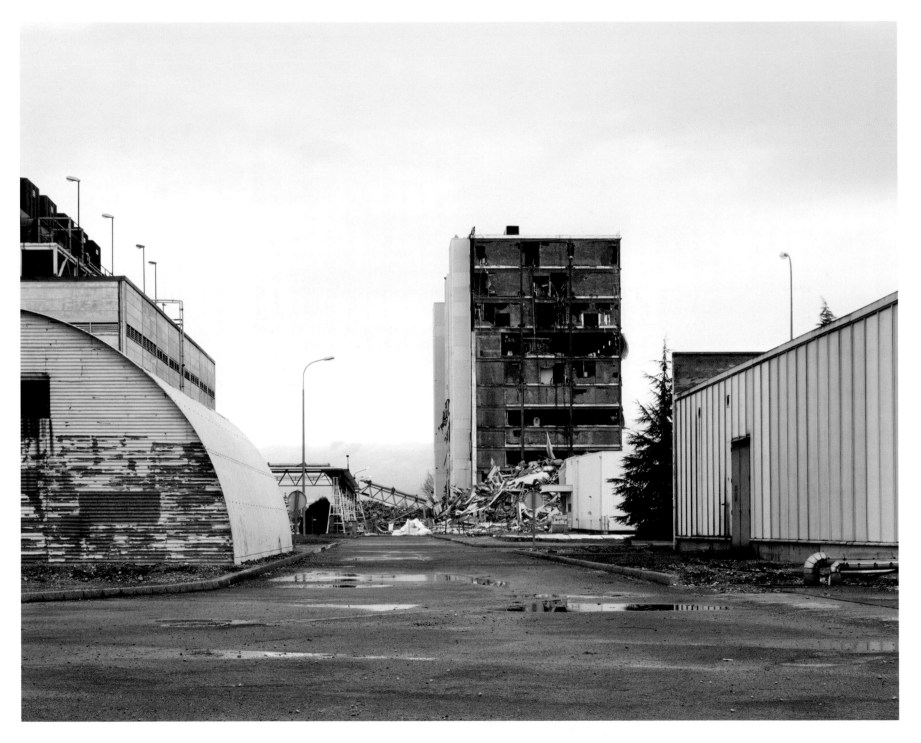

KODAK-PATHÉ PLANT, CHALON-SUR-SAÔNE, FRANCE DECEMBER 10, 2007

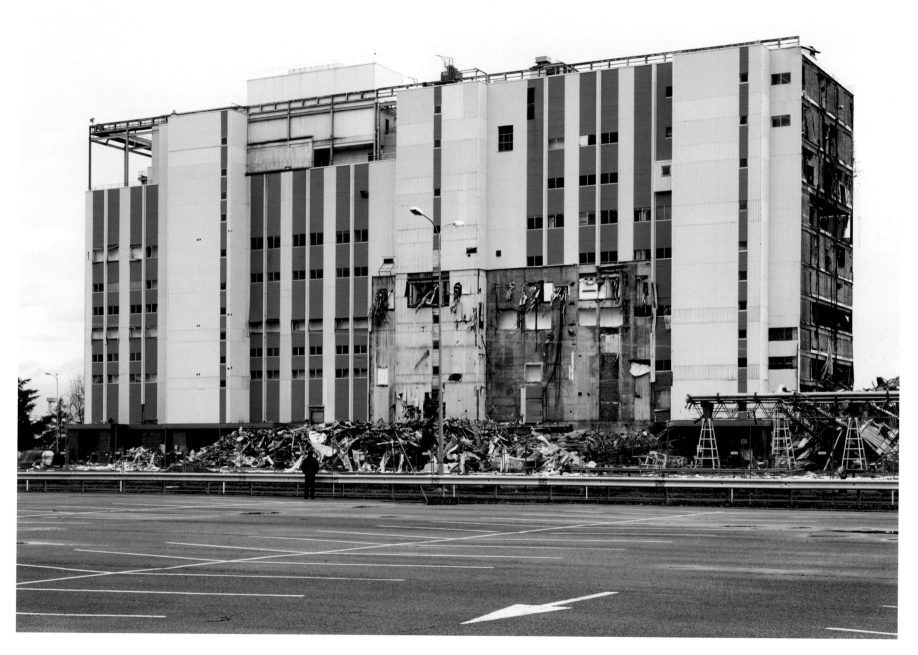

AFTER THE FAILED IMPLOSION OF THE KODAK-PATHÉ BUILDING GL, CHALON-SUR-SAÔNE, FRANCE DECEMBER 10, 2007

In 1894, Belgian photographer-entrepreneur Lieven Gevaert established his photographic paper company, Gevaert & Cie, in Antwerp. Ten years later, he moved his flourishing business to Mortsel, a quiet suburb just south of the city. Like the Kodak factory established by George Eastman in Rochester, Gevaert's modest manufacturing operations grew exponentially at the beginning of the twentieth century in response to the rapidly increasing demand for his films and papers, from both amateurs and professionals. Also like Eastman, Gevaert was ambitious, innovative, and a visionary. After merging with the German company Agfa in 1964, his sprawling complex expanded again to become the largest photographic company in Europe, and a strong competitor of Kodak.

While Gevaert's history is still reflected in the smaller brick structures that date from the company's early years, these low-rise buildings are now dwarfed by enormous white, window-less coating facilities dedicated to the mass production of photographic film in darkened spaces. During the latter half of the twentieth century, society found more uses for photographic film than either Gevaert or Eastman could have ever imagined. The demand did not last. By the time this photograph was made, the consumer division of the company, AgfaPhoto, located in nearby Leverkusen, Germany, had declared bankruptcy; in 2004, it shut down its factory and laid off all its employees. Agfa-Gevaert lives on in Mortsel, but is now limited to making specialized medical and aerial films, in buildings on the verge of outliving their own usefulness.

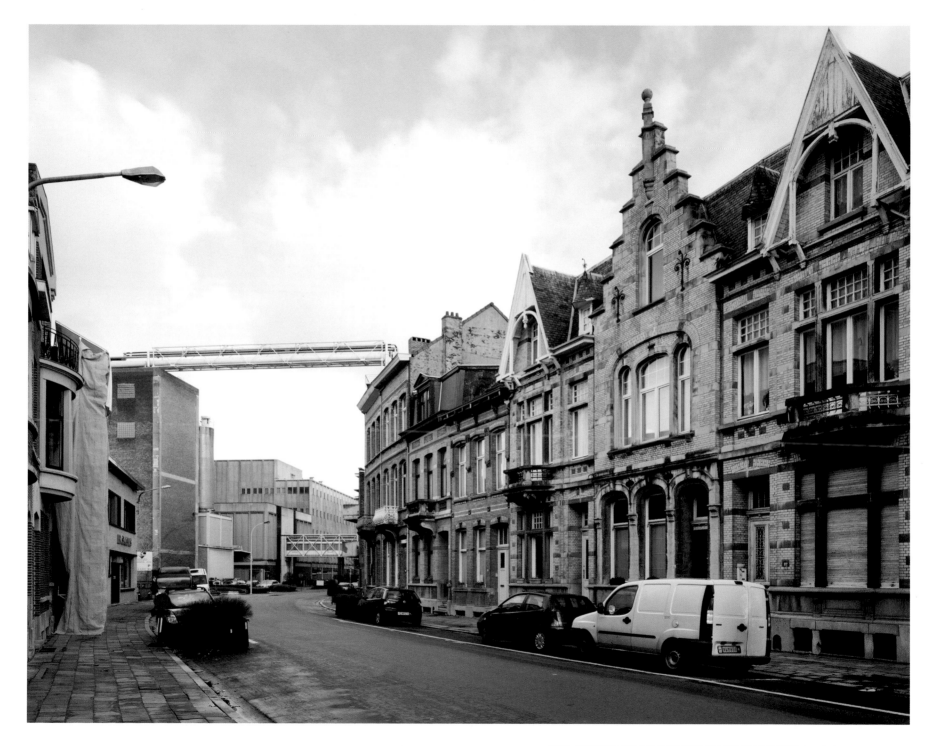

AGFA-GEVAERT FROM HENDRIK KUIJPERSSTRAAT, MORTSEL, BELGIUM 2007

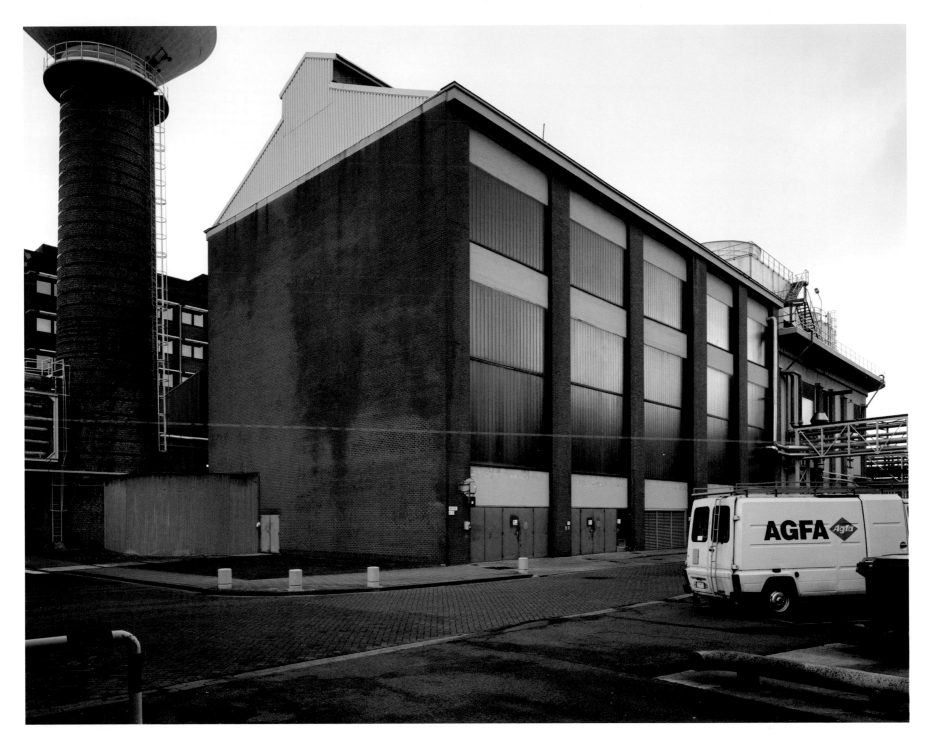

KETTLE HOUSE, AGFA-GEVAERT, MORTSEL, BELGIUM 2007

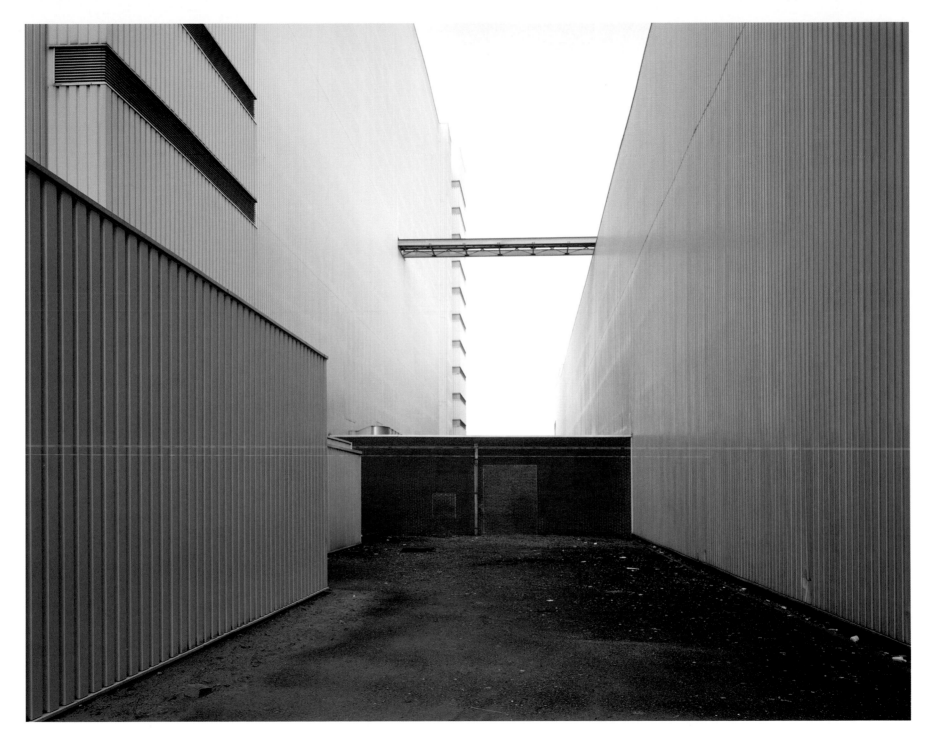

FILM COATING FACILITY, AGFA-GEVAERT, MORTSEL, BELGIUM [#1] 2007

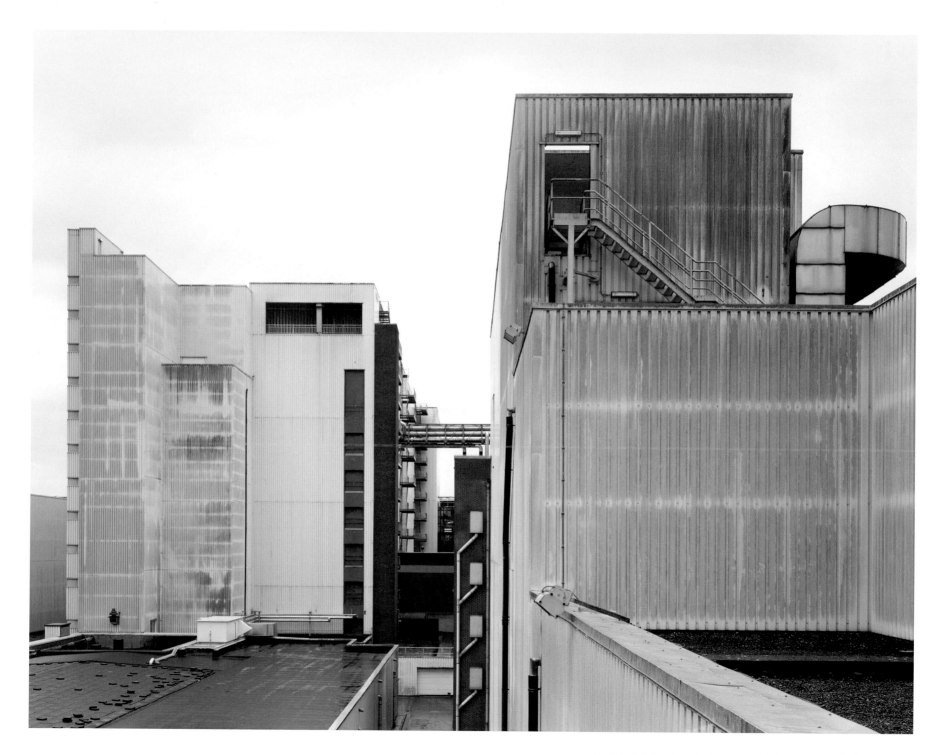

FILM COATING FACILITY, AGFA-GEVAERT, MORTSEL, BELGIUM [#2] 2007

The economy of scale required in the manufacture of photographic film only becomes evident when confronted by the spaces in which the product is made or stored. The small rolls that photographers use (or used) in their cameras start out as enormous master rolls manufactured to high standards in a very few specialized facilities around the world. These rolls are some 54 inches wide by as much as 2 miles long. A typical master roll will produce approximately 50,000 rolls of 35mm film, or over forty hours of 35mm motion picture film. This Agfa warehouse contains an estimated 1,500 master rolls of film—enough to make 73,500,000 rolls of 24-exposure 35mm film.

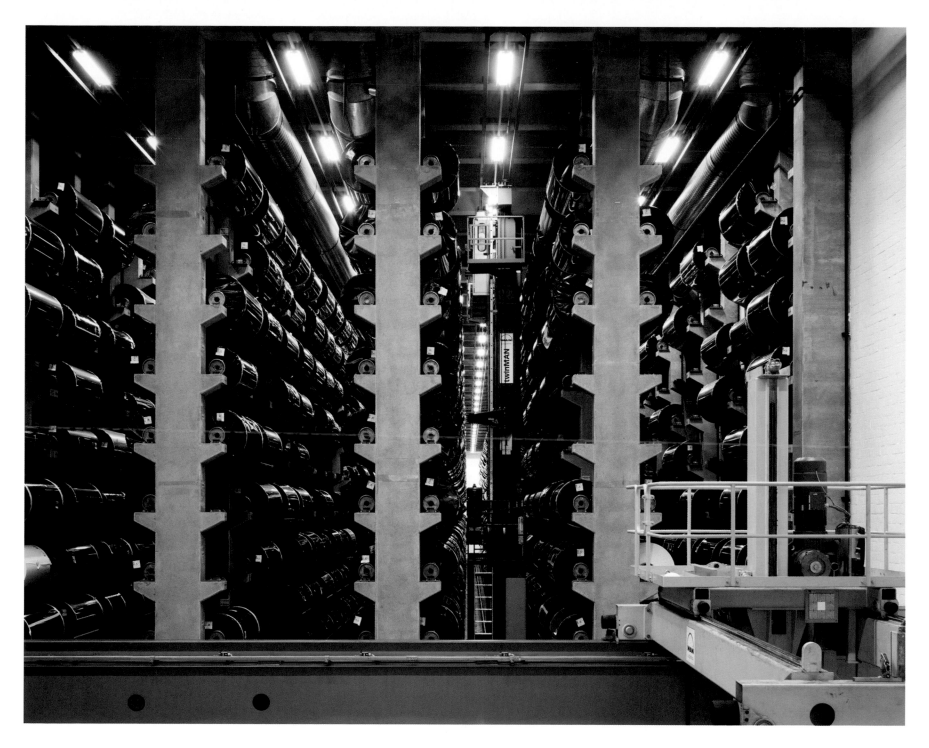

FILM WAREHOUSE, AGFA-GEVAERT, MORTSEL, BELGIUM 2007

EASTMAN KODAK

ROCHESTER, NEW YORK, U.S.A.

At its peak in the 1980s, Kodak employed more than 60,000 people in Rochester, New York —more than a quarter of the city's population at the time. When George Eastman founded the Eastman Kodak Company in 1892, it quickly became an American business legend, ultimately making Rochester's economy the second largest in the state after that of New York City.

Eastman not only provided jobs in Kodak Park, but he also had a hand in every aspect of Rochester's civic life. He founded its illustrious music and dental schools, endowed its university, and created the Community Chest (later known as the United Way). Over the course of the twentieth century the city became known as "Smugtown," in part because its economy seemed invincible. Depressions and economic downturns had no significant effect: people always needed film. To be employed by Kodak meant having a lifetime job with a good salary and benefits. George Eastman was one of the first businessmen in America to grant employees dividends and profit sharing. "Bonus Days" were well-known to retailers in Rochester, who extended store hours so Kodak employees could spend their annual windfalls.

The first rumblings of trouble for Kodak came in the early 1990s, when the company began to face stiff competition from overseas, and embarked upon disastrous forays into new products and businesses. By 2000, the digital revolution and the subsequent huge drop in demand for traditional films and papers had pushed the company into economic free-fall. By 2011, Kodak employed fewer than 7,000 people in Rochester, and was struggling to transform itself into a digital company.

There are two Kodak building complexes in Rochester: the company's head offices in Kodak Tower located in the downtown core on State Street; and the manufacturing, research, and warehousing operations in Kodak Park located in the northwestern part of the city. Upon its completion in 1916, Kodak Tower was Rochester's tallest building. When, in 1929, he saw the plans for the new Times Square Building, also to be located in downtown Rochester, George Eastman added three floors and a spire to Kodak Tower so that the company's headquarters could maintain its status as the city's tallest structure.

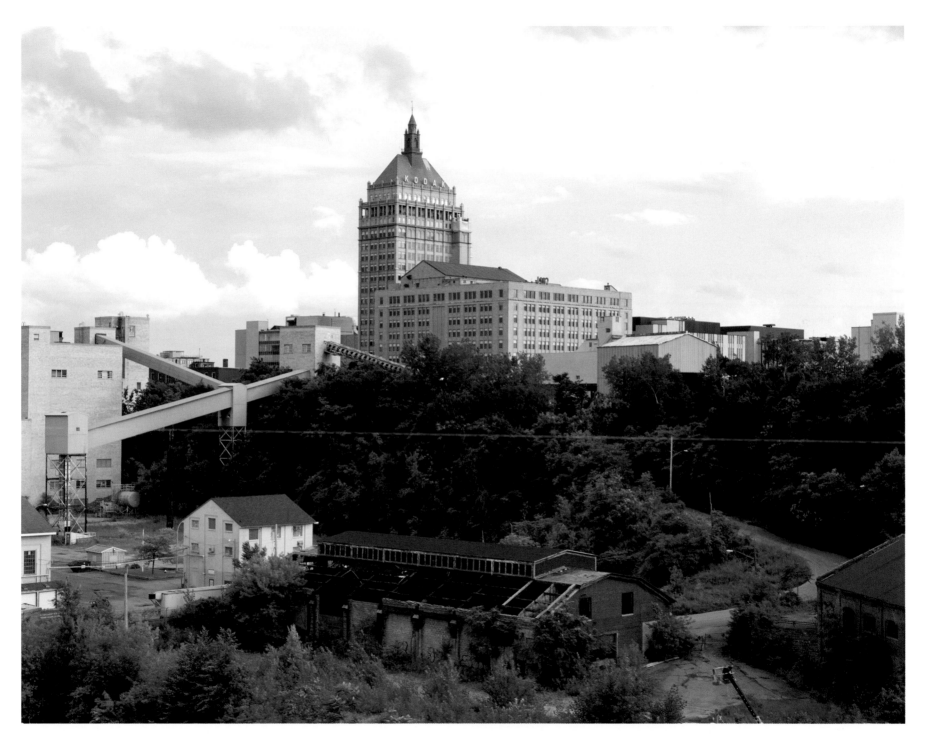

VIEW OF KODAK HEAD OFFICES FROM THE SMITH STREET BRIDGE, ROCHESTER, NEW YORK 2008

On March 12, 1932, George Eastman took his own life with a single gunshot to the heart. He left a handwritten note on his bedside table:

To my friends
my work is done
why wait?

Diagnosed with a degenerative spinal disease two years earlier, Eastman had planned his death with the same focus and painstaking precision with which he lived his life, to the extent of hiding a second Luger in the bookcase next to his bed in case the first misfired. At 3:30 p.m. on the day of his funeral, the lights in Rochester's movie houses were dimmed for one minute and the bell at City Hall struck seventy-seven times, one for each year of the industrialist's life. He died unmarried, and was survived by a niece, an estranged nephew, and their families.

Plans to bury Eastman next to his parents and sister Emma Kate in the nearby Waterville cemetery were changed after Kodak officials intervened, motivated by the desire to create a monument in his memory. On September 15, 1934, the George Eastman Memorial, constructed at the entrance to Kodak Park, was silently unveiled by Eastman's niece, Ellen Dryden, before a crowd of one thousand. Eastman's ashes are interred in a bronze urn buried beneath a Georgia marble pillar in a small park-like setting encircled by one of the largest factory complexes in the northeast United States. It is an unlikely and lonely resting place, chosen by Kodak executives who ironically wished to guard the private nature of the man who built the company. In 2012, Kodak Park's future was uncertain, as was the final resting place of the man behind Kodak.

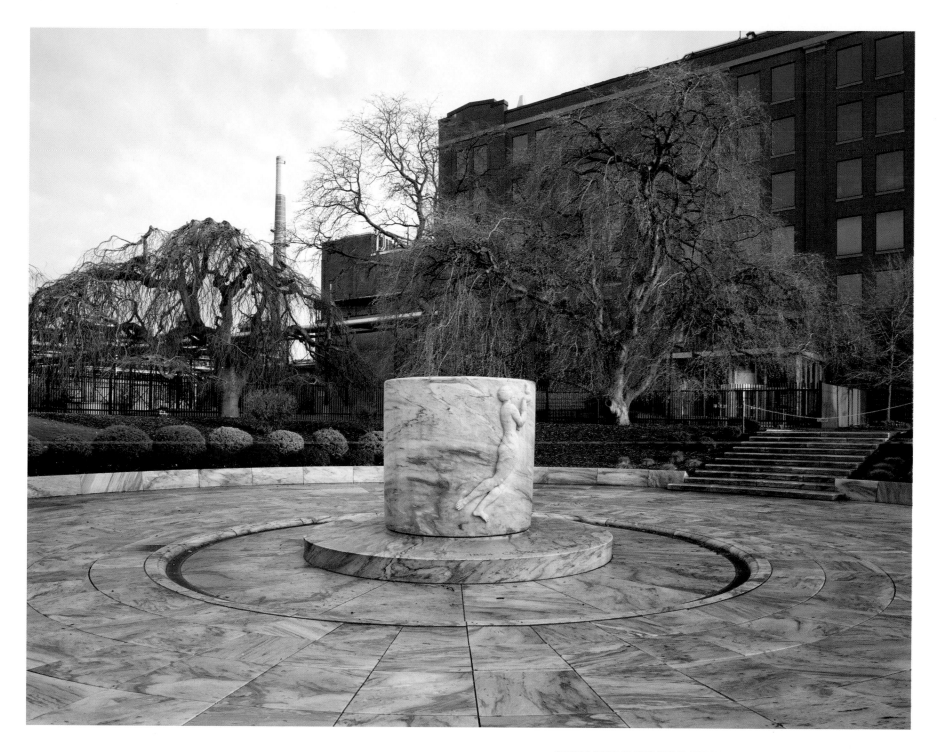

GEORGE EASTMAN MEMORIAL, KODAK PARK, ROCHESTER, NEW YORK 2010

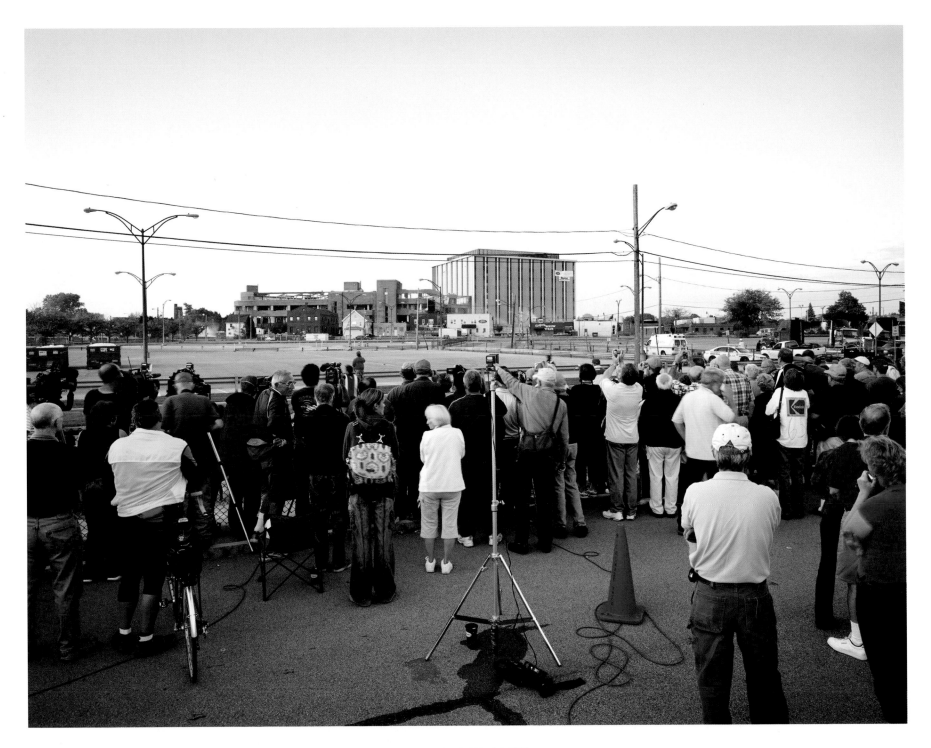

AWAITING THE IMPLOSIONS OF BUILDINGS 65 AND 69, KODAK PARK, ROCHESTER, NEW YORK OCTOBER 6, 2007

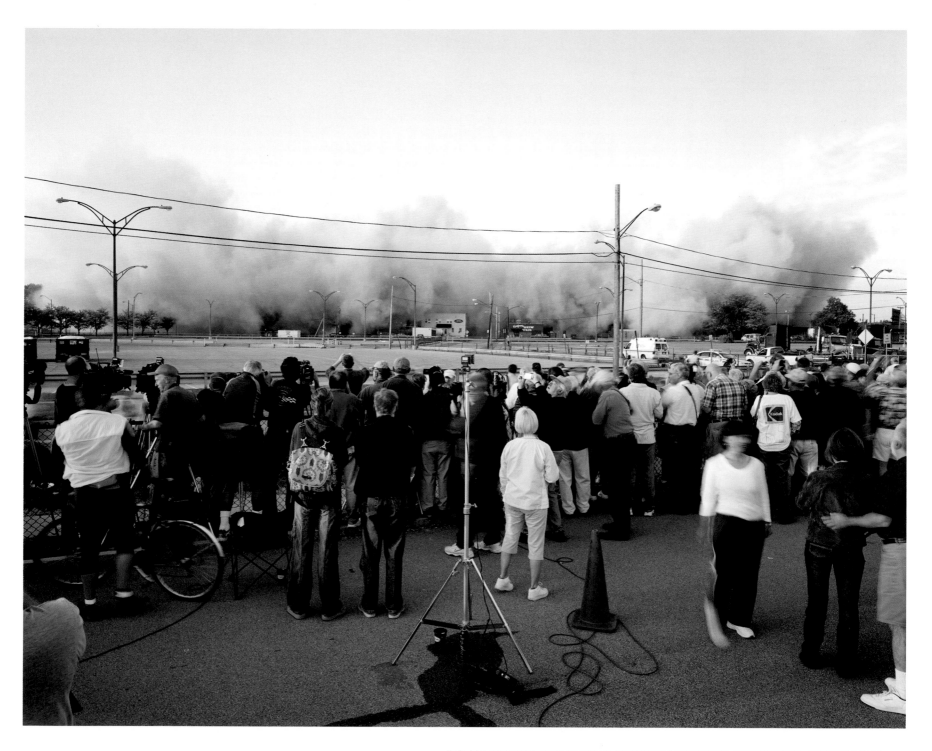

IMPLOSIONS OF BUILDINGS 65 AND 69, KODAK PARK, ROCHESTER, NEW YORK [#1] OCTOBER 6, 2007

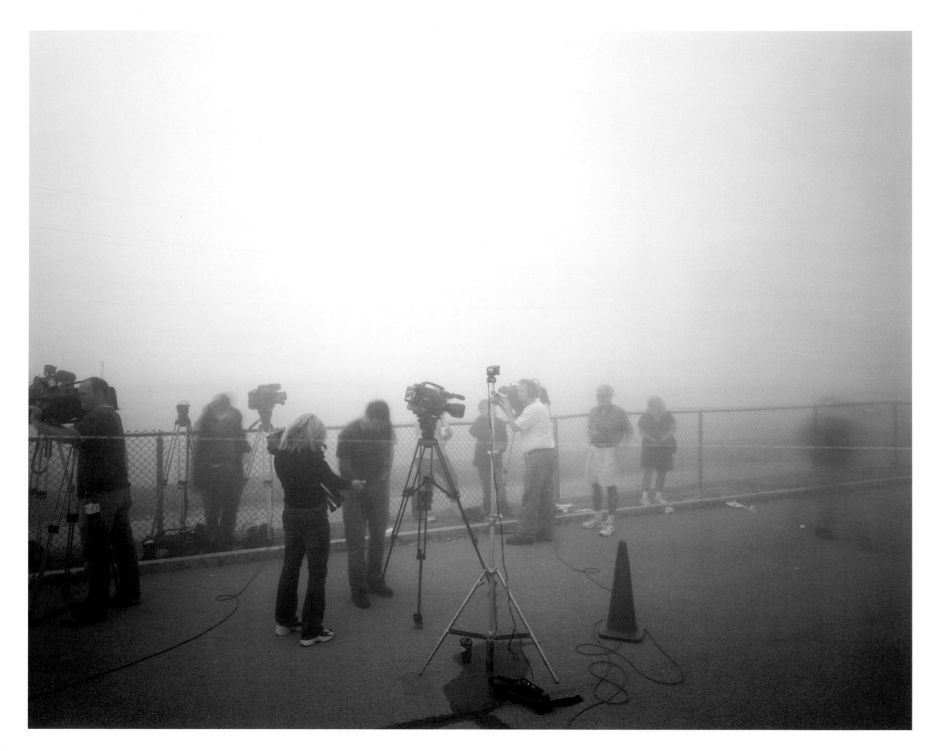

IMPLOSIONS OF BUILDINGS 65 AND 69, KODAK PARK, ROCHESTER, NEW YORK [#2] OCTOBER 6, 2007

Over a two-year period starting in 2006, Eastman Kodak demolished over fifty structures in Kodak Park. In addition, the company sold off a number of office and warehouse buildings to reduce its footprint, from 1,600 acres down to 700. During this time, Kodak also shrank its global workforce by over 25,000 employees, and reported losses in the billions of dollars.

In 2007 there were four scheduled implosions of factory buildings that had previously been dedicated to the manufacturing of photographic products. This series of images shows the demolition of Buildings 65 and 69 on October 6, 2007. To be in attendance at these events was to experience something thrilling and disheartening at once. The thrill came from the deafening explosions and the unreal collapse, only taking seconds, of an enormous and cavernous building. This was invariably followed by an eerie silence; spectators, many of whom were former employees and had spent the better part of their lives working in these buildings, quietly got into their cars and went home. In each instance, I believe, I was one of the few photographers recording the event on film. When I looked into the crowds in front of my view camera, I saw an array of digital devices—cell phones, camcorders, and cameras—capturing a final "Kodak moment."

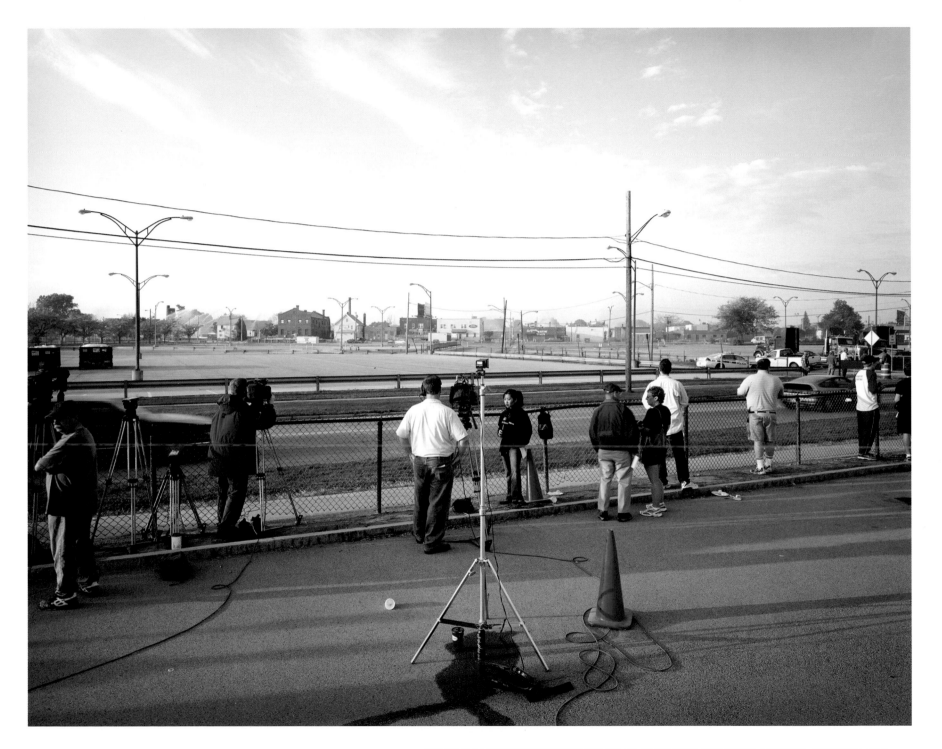

AFTER THE IMPLOSIONS OF BUILDINGS 65 AND 69, KODAK PARK, ROCHESTER, NEW YORK OCTOBER 6, 2007

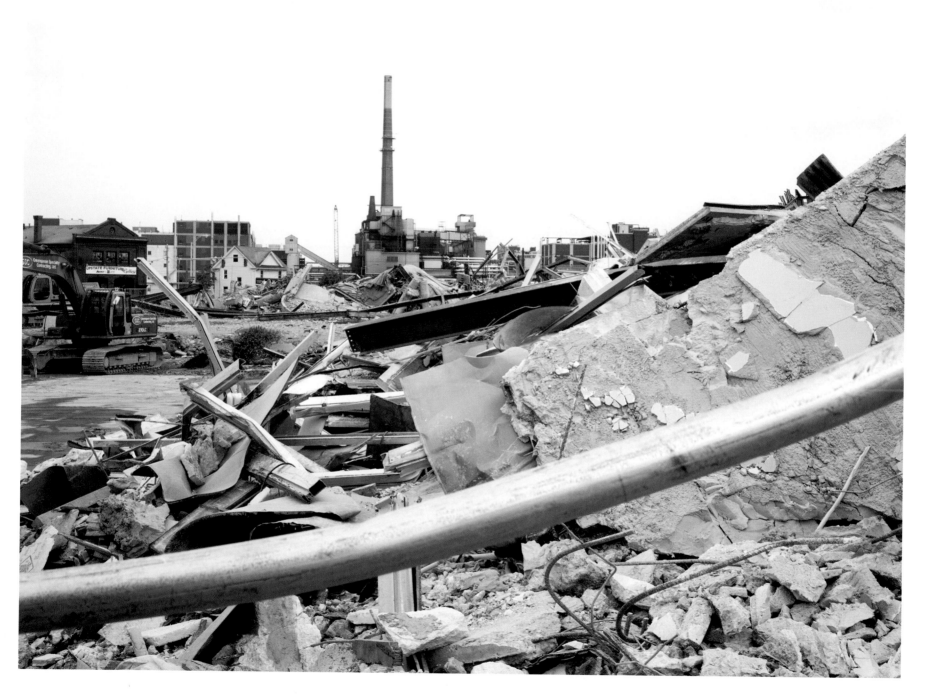

WRECKAGE OF BUILDINGS 65 AND 69, KODAK PARK, ROCHESTER, NEW YORK 2007

In 2008, Kodak estimated it would need only half of the remaining Kodak Park for its future operations. Kodak Park was renamed Eastman Business Park as a way to encourage other businesses to lease the new abundance of empty factory space. By 2012 a number of smaller companies had begun to establish themselves in the Park, namely those started by former Kodak employees who had taken early retirement or been laid off as the company downsized. Soon this cluster of modest-sized businesses, with operations ranging from manufacturing solar cells to making spaghetti sauce, employed about 6,500 people, a figure outnumbering Kodak's remaining Rochester workforce.

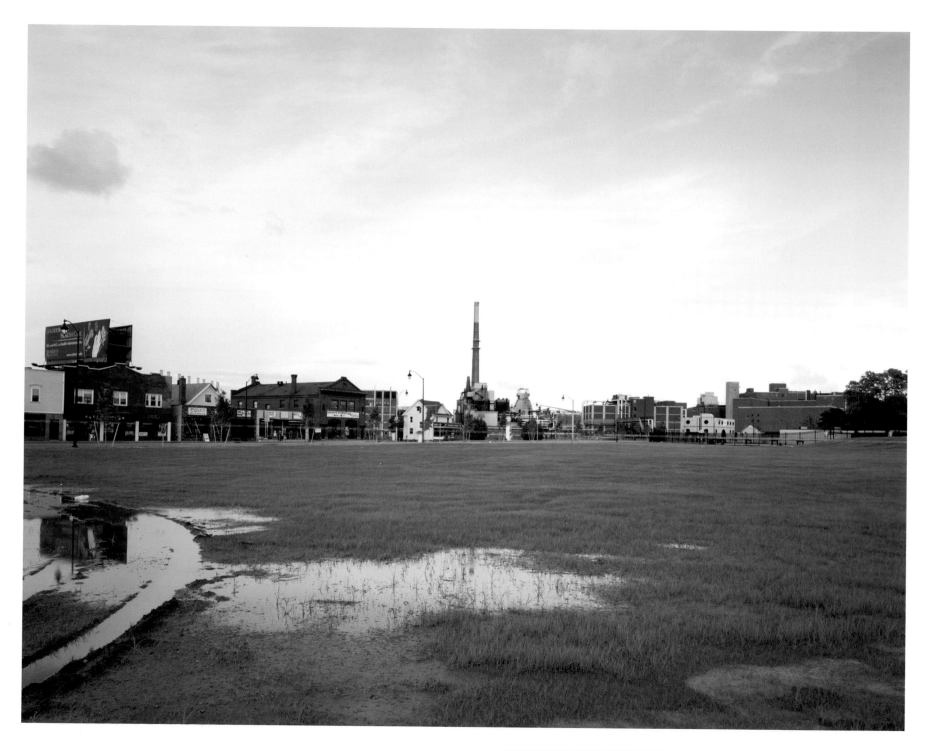

GRASS ON SITE OF BUILDINGS 65 AND 69, KODAK PARK, ROCHESTER, NEW YORK 2008

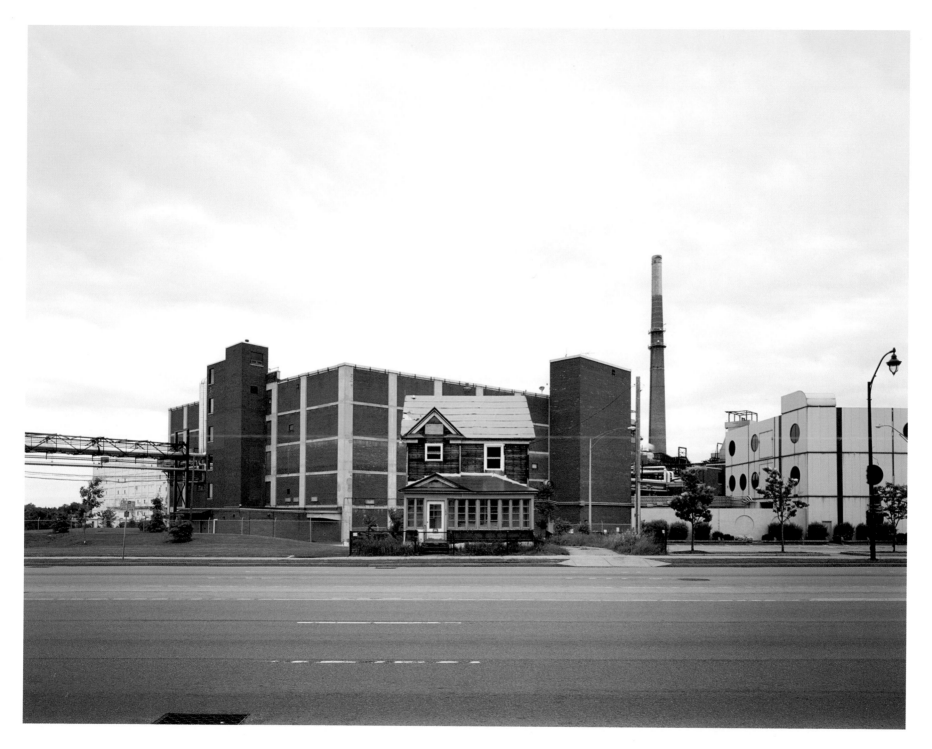

KODAK PARK, VIEW OF 246 RIDGE ROAD WEST AND BUILDING 56, ROCHESTER, NEW YORK 2010

In January 2012, after its stock price had dropped below the fifty-cent mark, the Eastman Kodak Company filed for bankruptcy protection and was de-listed from the New York Stock Exchange. The fall of this iconic American company, whose name had become synonymous with photography, was both inevitable and unbelievable, but also disheartening for the generations who had trusted this brand with its most treasured possessions: their memories. Almost overnight these same customers had shifted from developing film and printing photographs to embracing the instantly shareable digital experience. Unfortunately for Kodak, the latter didn't require photographic film or paper.

Ironically, it was here at Kodak Park, in 1975, that a young research engineer named Steven Sasson invented the first digital camera—the disruptive device largely responsible for the corporate giant's collapse. While Kodak went on to patent innumerable innovations in digital imaging technology over the next thirty-five years, profit-conscious executives were hesitant in introducing these ideas, for fear of undermining their profitable film business. But just as the Lilliputians took a giant Gulliver prisoner while he slept, so too did smaller digital companies, riding the sweep of technological change, topple the Rochester titan. Within three weeks of seeking protection from creditors, Kodak also announced it would stop manufacturing cameras—the product that had defined the company since it was first established in 1892. One week later, it announced it would remove its name from the illustrious Kodak Theatre in Hollywood, home of the annual Academy Awards ceremonies. Less than a month later, *The Artist*, a black-and-white silent film that paid homage to the early film-based days of cinema, won "Best Picture."

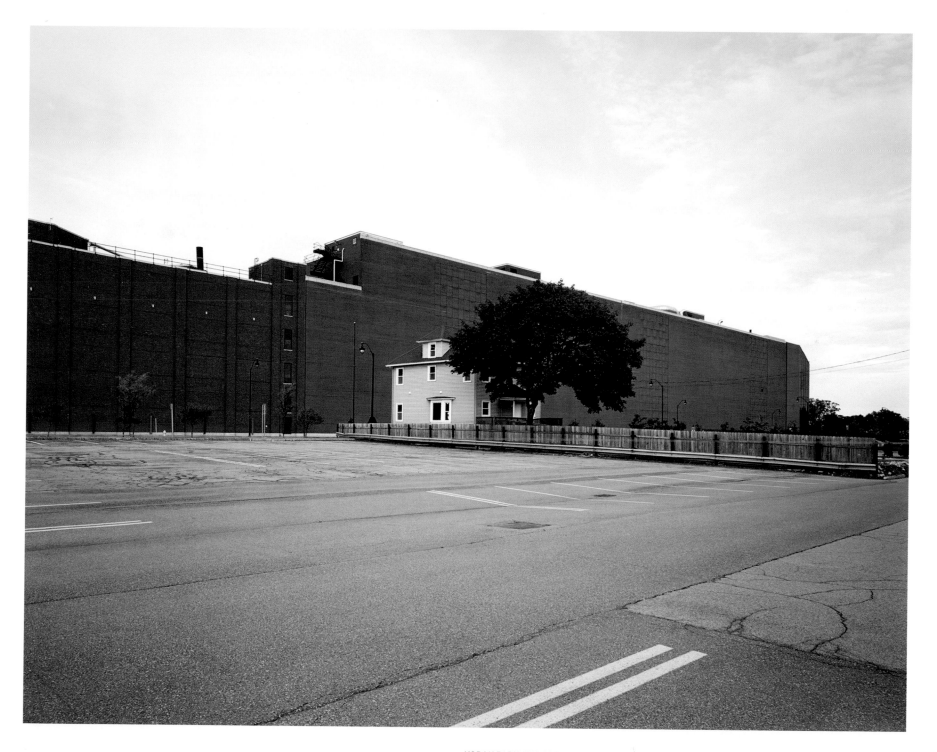

KODAK PARK, VIEW OF JAVIER'S BARBER SHOP AND BUILDING 29, ROCHESTER, NEW YORK 2011

POLAROID
WALTHAM, MASSACHUSETTS, U.S.A.

Polaroid Corporation was founded by the physicist and inventor Edwin Land in 1937 after he dropped out of Harvard at the age of nineteen to pursue the development of his innovative polarizing filters. Soon, Land became consumed by the dream of making photography "instant," and in 1948 the dream became reality when he introduced a revolutionary camera and film system with the slogan, "Snap it…see it!" His instant peel-apart film let consumers bypass the trip to the drugstore to drop off their film, as well as the two-week wait for their processed prints to be returned. The groundbreaking invention quickly found applications in science and police work; photographers, amateur and professional, were already sold on the novelty of producing private photographs.

Land, realizing his camera might also appeal to artists, hired modernist photographer Ansel Adams as a consultant in 1949. Adams became not only a spokesman for Polaroid, but was also involved in the testing and development of the company's professional products during the 1950s and 1960s.

As Polaroid grew, Land remained true to his roots in science by creating a company that attracted like-minded researchers and allowed them to explore a myriad of innovative ideas related to photography. It could be argued that Land and Polaroid were the last true pioneers of traditional photography in the twentieth century, introducing one new invention after another, culminating in the groundbreaking SX-70 camera and film system introduced in the early 1970s.

Polaroid had its headquarters and main research labs in Cambridge, Massachusetts, while the factory complexes were located outside the city in Waltham and Norwood. Even the factory and offices were constructed to reflect Polaroid's reputation as an incubator for ideas: employees dressed casually and worked in a handsomely designed environment; everyone, from the researchers to factory workers, was encouraged to contribute to the next big idea. Modern day equivalents to Polaroid's communal style would be companies like Steve Jobs's Apple, or Google. Even today, the Polaroid building complexes appear to have been designed as vocational havens, more along the lines of a university than a corporate compound. The Waltham campus was situated on a 120-acre site that was exquisitely landscaped; the employee cafeteria was designed by the Finnish architect Alvar Aalto.

The Waltham facility was closed in 2008 when Polaroid, after its second bankruptcy in ten years, announced that it would discontinue the production of all its instant films. Once having employed more than 15,000 people in Massachusetts, the Polaroid Corporation was reduced to a workforce of 1,500 by 2010, offering a variety of digital products, including camcorders, DVD players, and LCD screens. In 2011, it announced the production of a digital version of its instant camera.

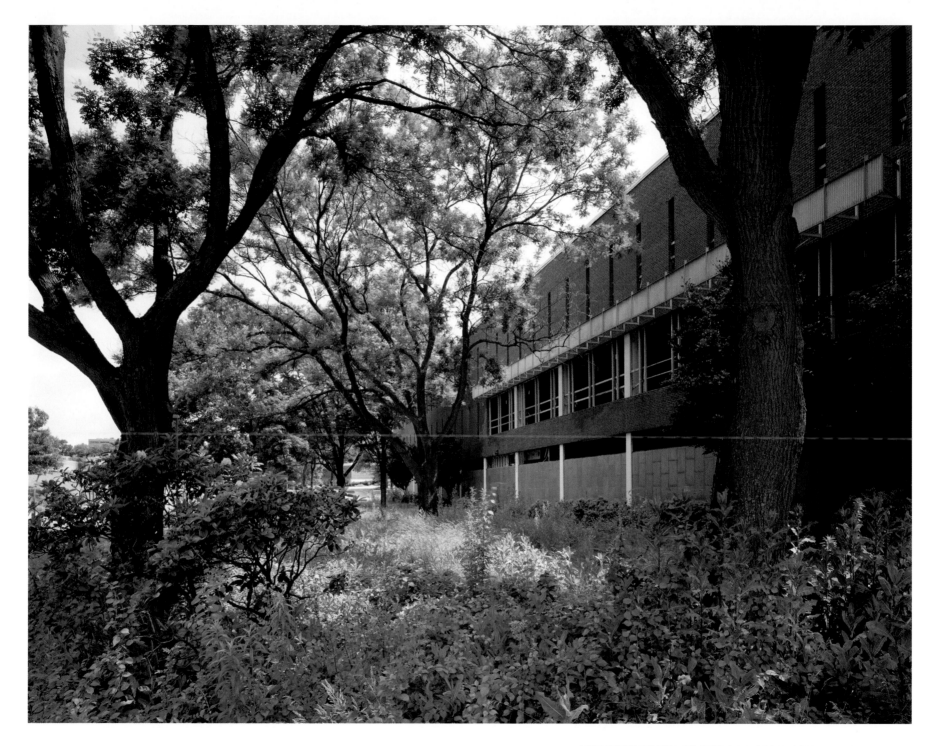

VIEW OF BUILDING W1, POLAROID, WALTHAM, MASSACHUSETTS 2009

Many industrial buildings that outlive their original purpose are converted to other uses by the next generation of architects, planners, and developers. For example, in the nearby city of Lowell, a group of nineteenth-century textile mills were converted into a cultural, retail, and residential development in the 1980s. This has not been the fate of the majority of film factories, because these buildings were designed for the specific needs of a unique and complex manufacturing process. Unsuitable for adaptation to other uses, most have been demolished to make way for new buildings.

The Polaroid complex in Waltham is an exception to this rule, in large part due to the fact that these buildings were used only to assemble and package the Polaroid films. A little known fact is that the film components of Polaroid products were manufactured by Kodak in Rochester and then shipped to Waltham. This meant that the Polaroid factory interiors were like most other manufacturing spaces: large, open floor plans. In 2010 the Polaroid site was purchased by a developer who began construction to convert it into an office and retail complex.

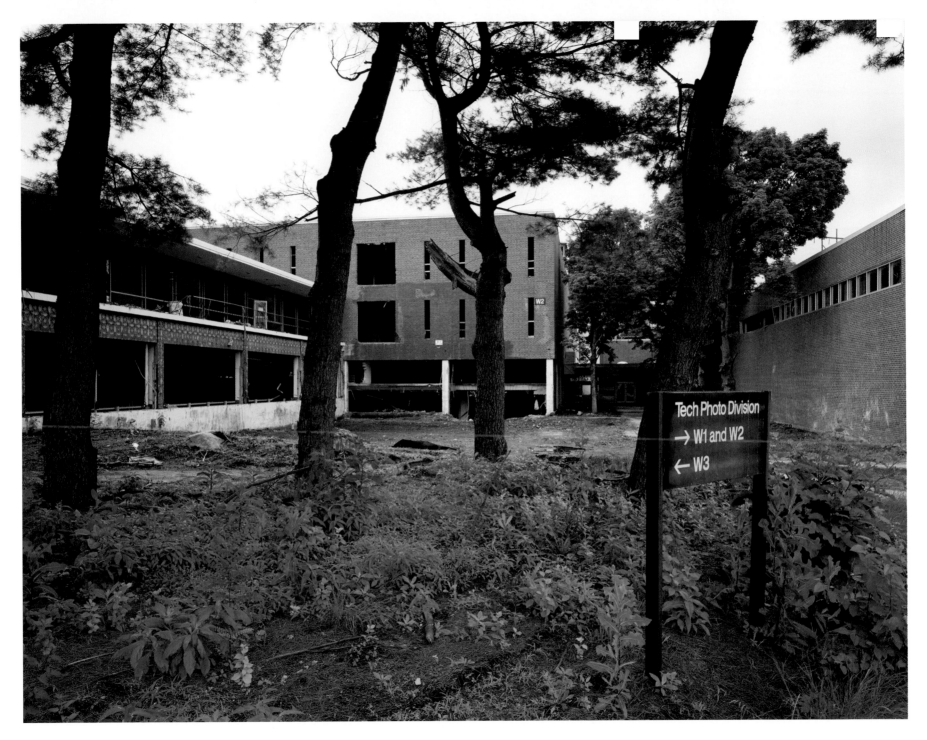

BUILDINGS W1 AND W2, POLAROID, WALTHAM, MASSACHUSETTS 2009

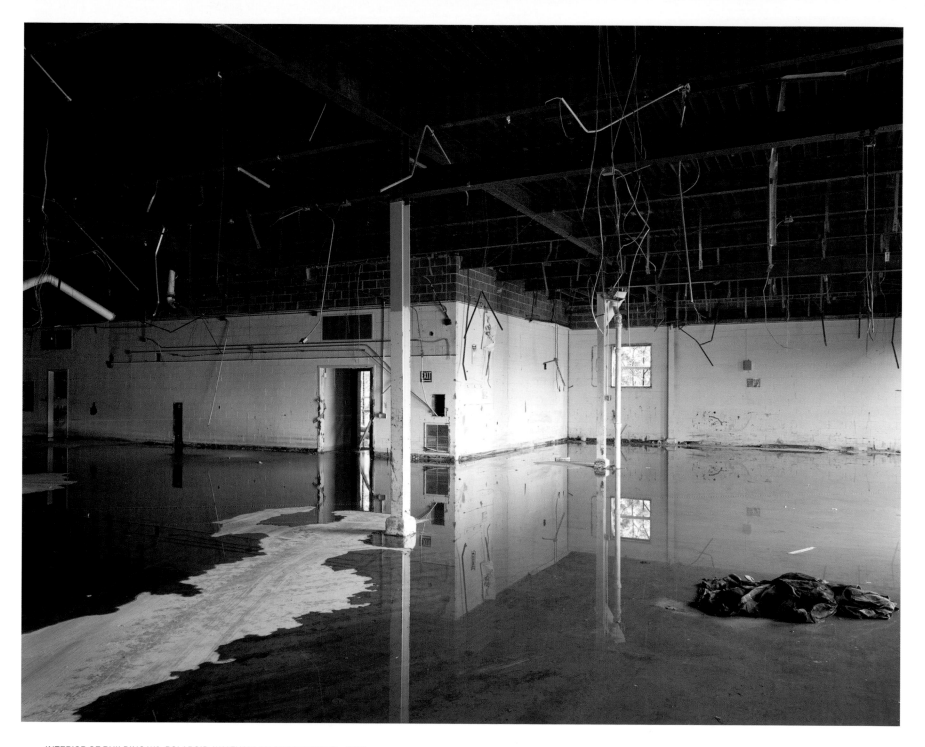

INTERIOR OF BUILDING W3, POLAROID, WALTHAM, MASSACHUSETTS 2009

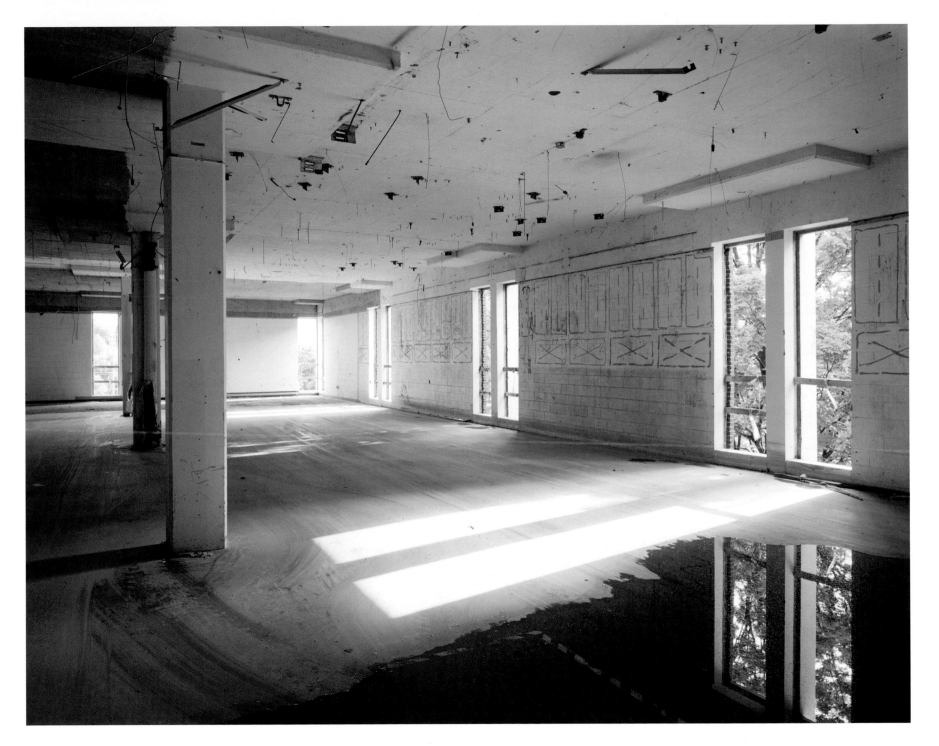

INTERIOR OF BUILDING W1, POLAROID, WALTHAM, MASSACHUSETTS 2009

After the Polaroid Corporation announced its plans to stop manufacturing instant films in 2008, a group of employees at the company's plant in the Netherlands got together to create a scheme for re-starting production. Led by Polaroid scientist André Bosman and Austrian entrepreneur Florian Kaps, the newly formed company was aptly named "The Impossible Project" (IP). Supported by private investors and the enthusiasm of Polaroid fans worldwide, Kaps, Bosman, and a group of workers set a goal of reintroducing a new instant film within two years.

The entrance to the IP building is timeworn. Looking out from the window is "Betsy," the mannequin used by both Polaroid and IP to test for the accurate reproduction of skin tones on film. Photographic companies have traditionally used photographs of female subjects to maintain quality control in their products and to provide a reference for photo labs using their materials. The practice began with Kodak, which used an employee named Shirley as its reference for skin tone reproduction. Hence the test negatives created by Kodak (included in the *Kodak Color Dataguides*) came to be known as "Shirleys."

As Bosman and his skeleton crew worked toward the reinvention of Polaroid integral films, Betsy, who along with the physical plant had seen better days, became the most photographed subject at the Impossible Project.

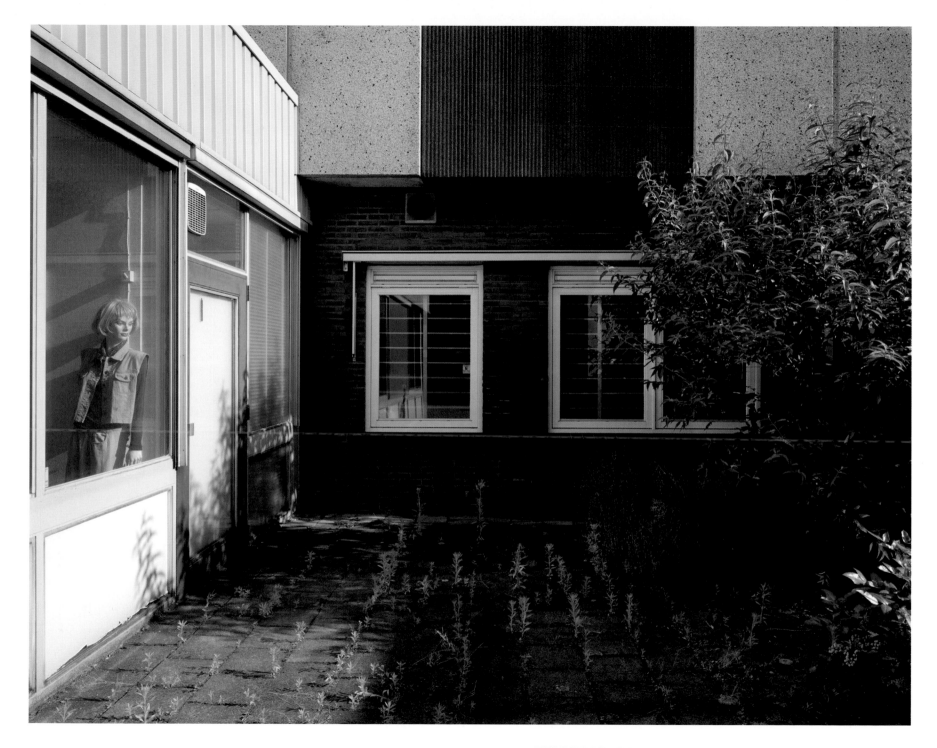

BETSY IN WINDOW, ENTRANCE, POLAROID, ENSCHEDE, THE NETHERLANDS 2010

Enschede, a town of 150,000 just west of the German border in the Netherlands, was home to Polaroid's European manufacturing facility and offices. Established in 1965, the plant employed 1,200 workers and produced 1.5 billion packages (about 35 million per year) of Polaroid integral and peel-apart films before it was closed in 2008. In 2011, the Impossible Project was renting one of eight buildings in the original complex and employing twenty-five workers, most of whom were previous Polaroid employees. By the end of 2011, the Impossible Project had produced just under one million boxes of film.

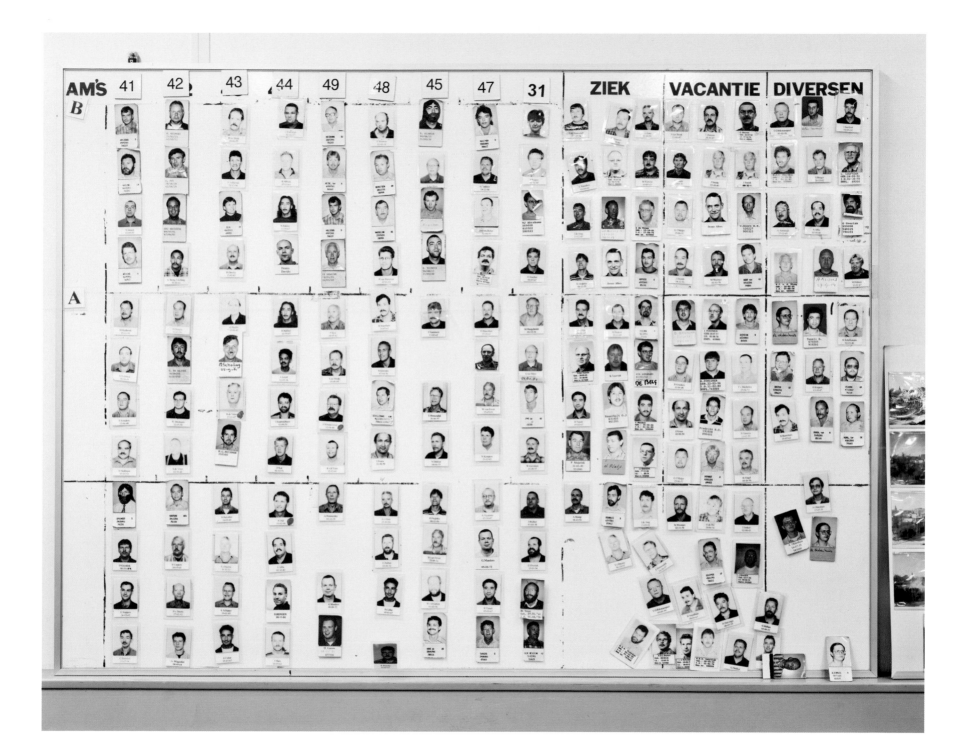

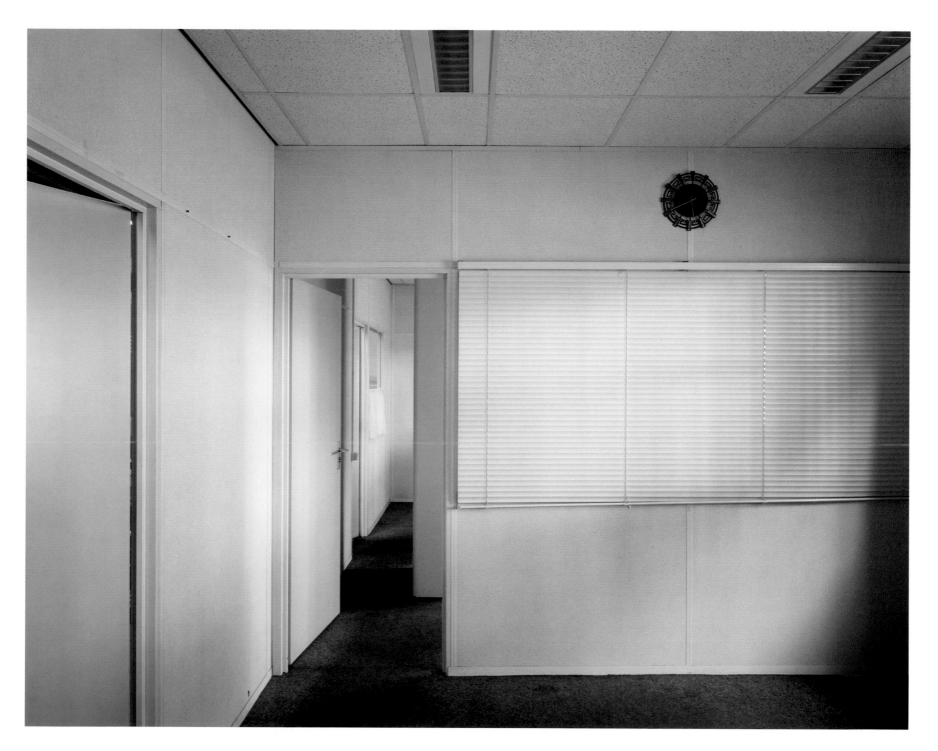

EMPTY OFFICES, POLAROID, ENSCHEDE, THE NETHERLANDS 2010

All photographic companies were founded on a collection of patents for their products. Edwin Land personally held 524 U.S. patents for Polaroid products. Photographic films were extremely profitable because they could be produced at a low cost and sold at high profit margins. For this reason, each company was extremely protective of its recipes for mixing chemical emulsions, as well as its methods for manufacturing films and papers. When the Enschede facility was taken over by the Impossible Project, the management team was able to secure the building and machinery used to make instant film, but was faced with the prospect of redeveloping all the chemical and material components from scratch. Not even the workers or researchers who had previously worked for Polaroid in Enschede had firsthand knowledge of the carefully guarded secrets held by their American counterparts.

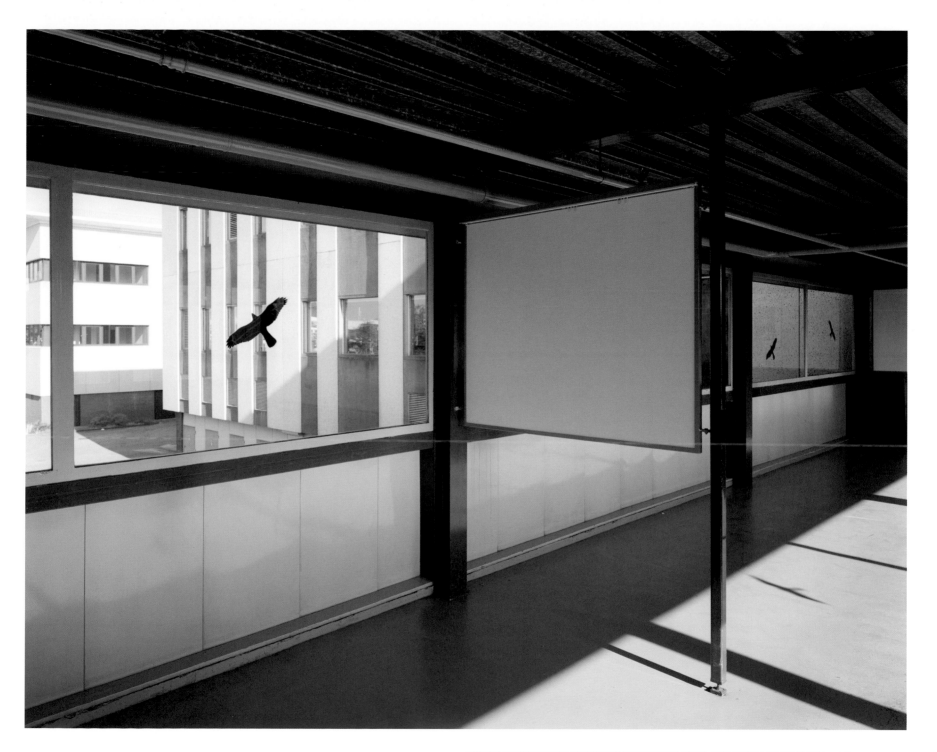

SKYWALK CONNECTING OFFICES TO FACTORY, POLAROID, ENSCHEDE, THE NETHERLANDS 2010

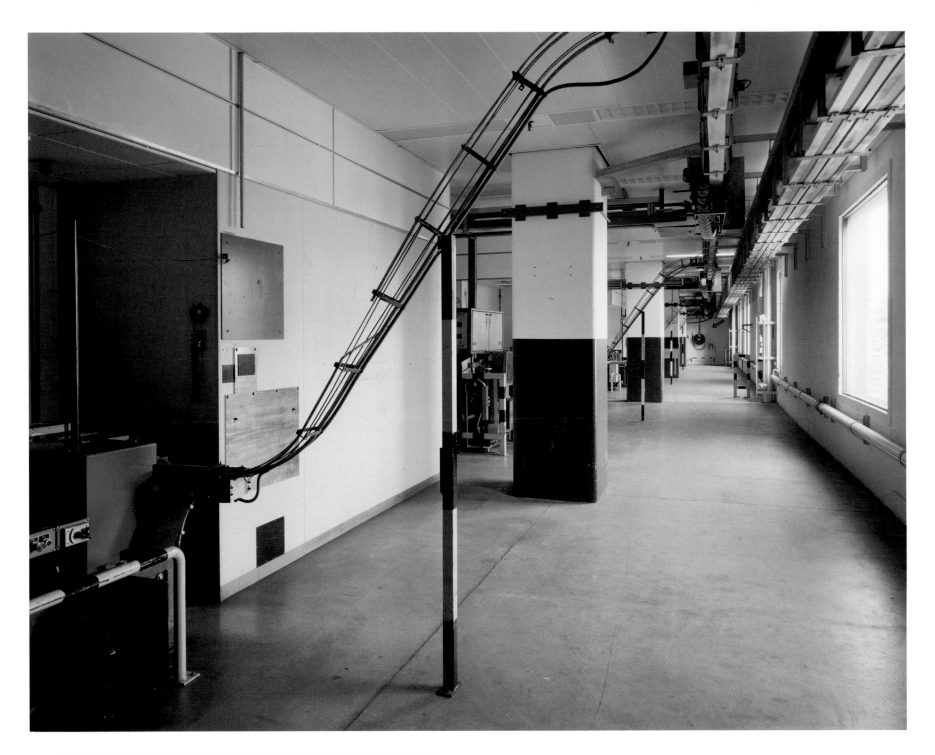

CORRIDOR IN MANUFACTURING AREA, POLAROID, ENSCHEDE, THE NETHERLANDS 2010

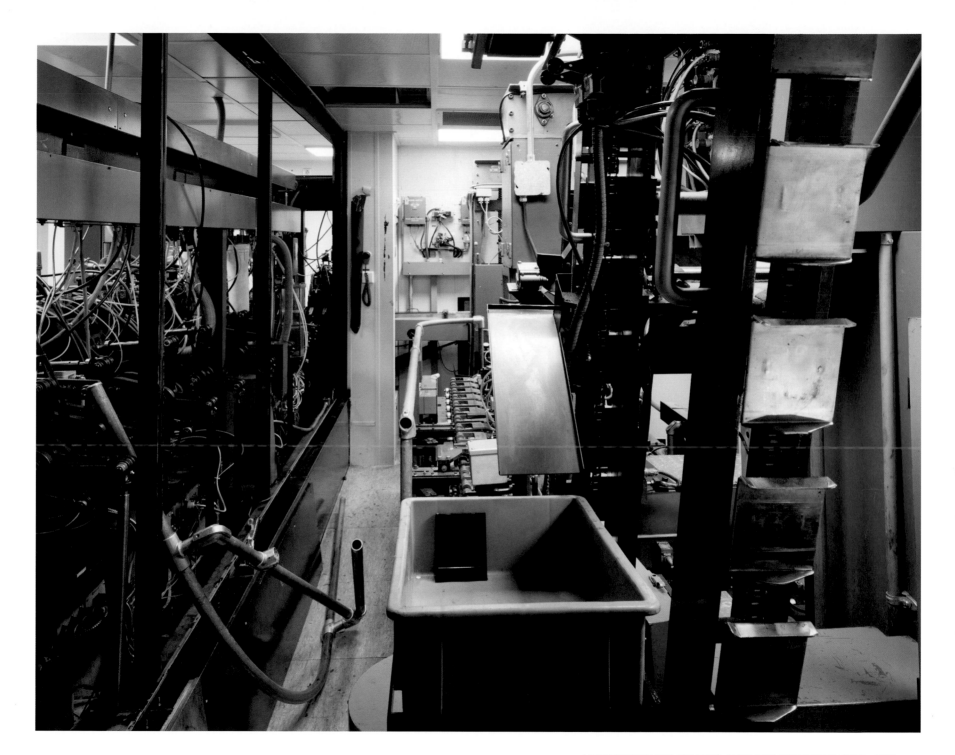

ASSEMBLY MACHINE, POLAROID, ENSCHEDE, THE NETHERLANDS 2010

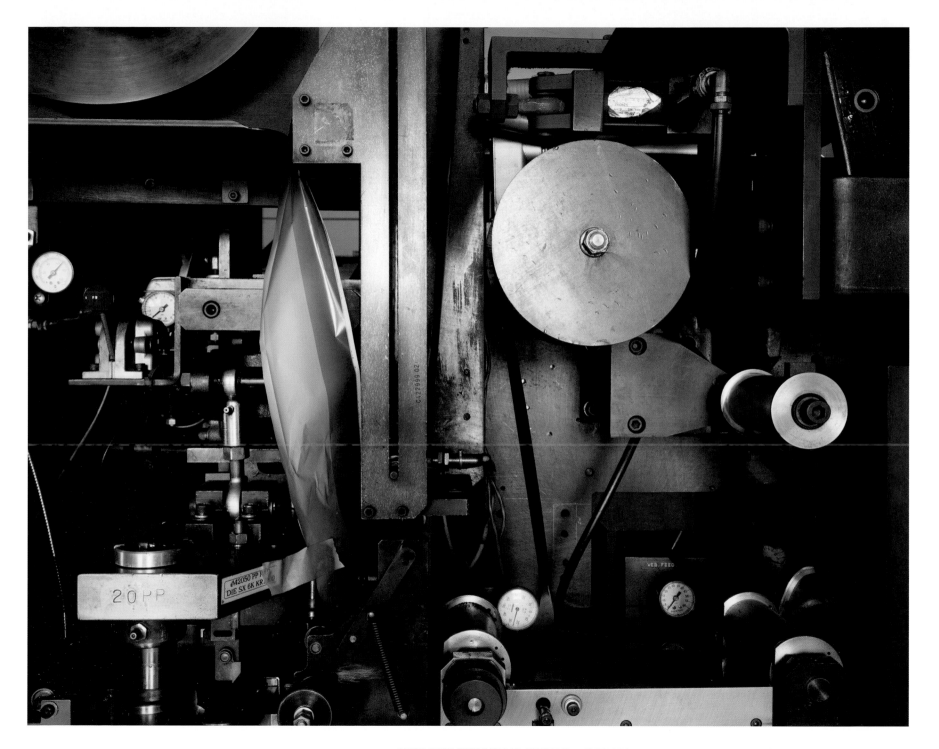

DETAIL OF MACHINE USED TO CREATE 8" x 10" POLAROID FILM, POLAROID, ENSCHEDE, THE NETHERLANDS 2010

In August 2004, the Ilford Company, which had just celebrated its 125th year in business, suffered a 26 percent plunge in sales, and was forced into bankruptcy. In October of the same year, the company's booth at the renowned Photokina trade fair in Cologne was deluged by photographers buying up the film and paper products they believed would not be available in the new year. At the end of the fair, Howard Hopwood, head of Ilford Brands Worldwide, attempted to reassure his panicked customers, stating that sales would continue for at least the eight weeks following the trade show: "There is still a demand for black-and-white papers and film…however, this doesn't mean that I think it will last forever." A team of U.K. Ilford managers, more confident about photography's future than their leader, banded together and, in February 2005, proposed a buyout and restructuring agreement. Four months later, in June, the Kodak Company quietly announced it would discontinue all its black-and-white photographic papers, a product line it had maintained since it was first established in 1888.

With their major competitor no longer in the game, Ilford emerged from receivership with a leaner workforce, fewer products, and a renewed focus on black-and-white photography.

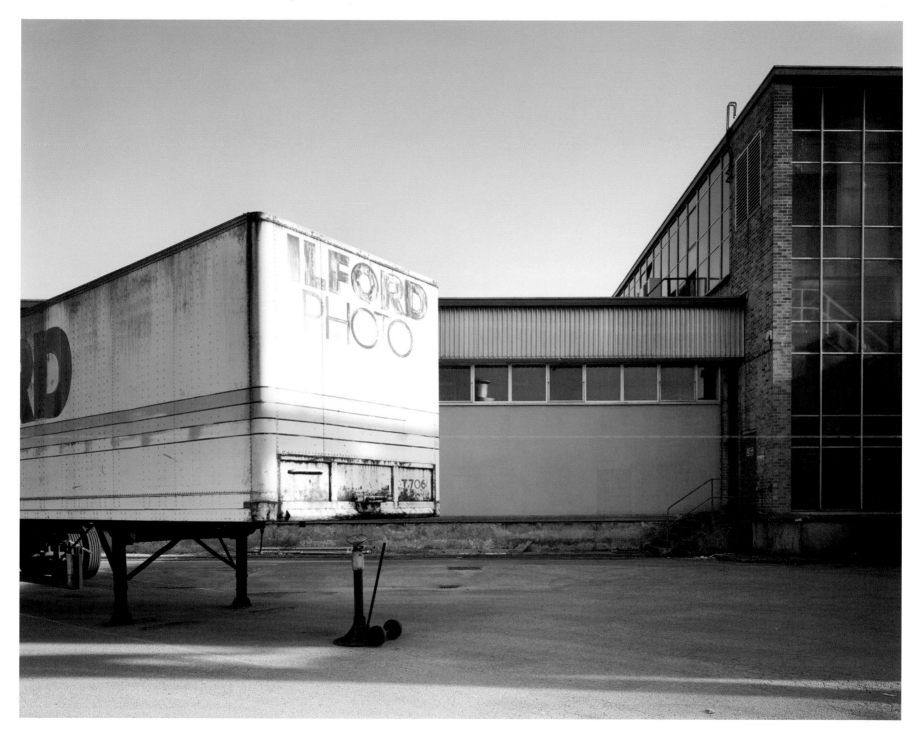

PAPER FINISHING BUILDING, ILFORD, MOBBERLEY, UNITED KINGDOM 2010

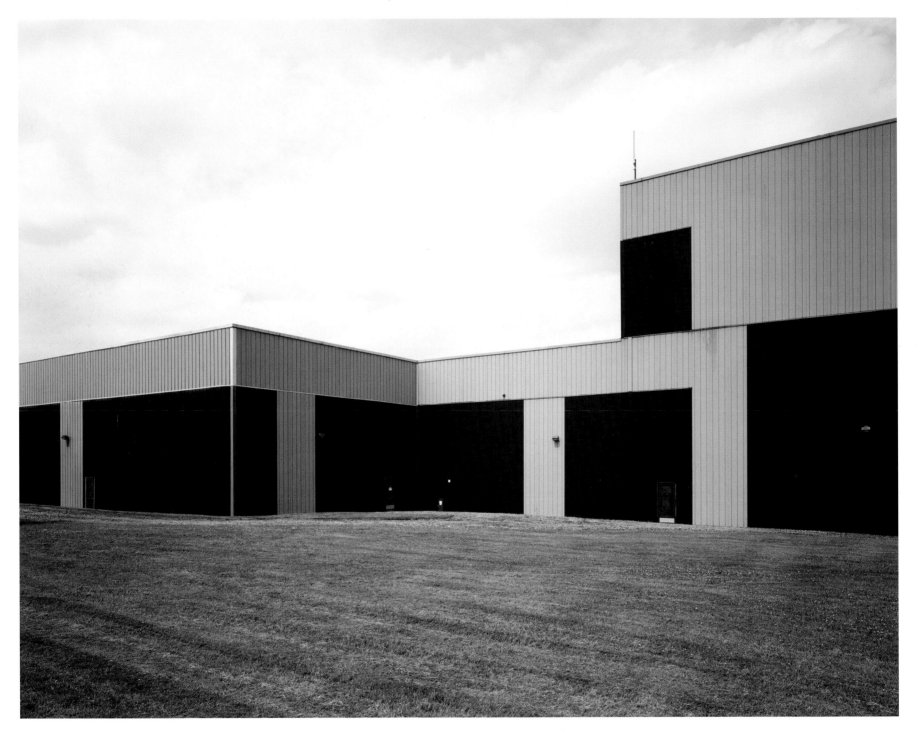

WAREHOUSE AND PHOTO-CHEMISTRY BUILDING, ILFORD, MOBBERLEY, UNITED KINGDOM 2010

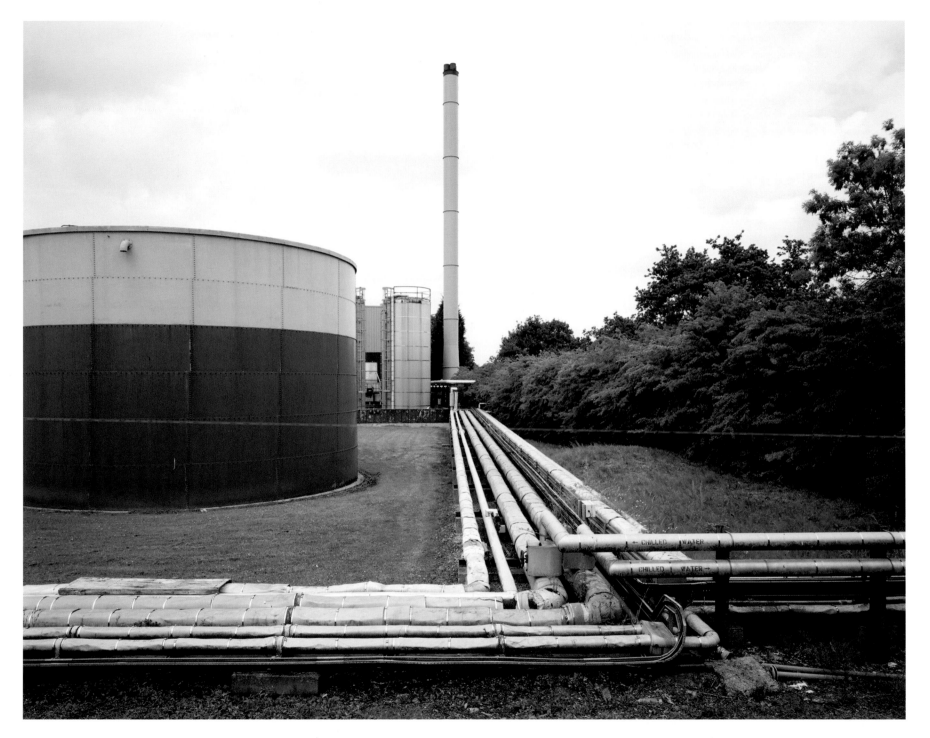

POWER PLANT, ILFORD, MOBBERLEY, UNITED KINGDOM 2010

Manufacturers of photographic products are essentially chemical companies, dependent on the knowledge of research chemists and chemical engineers. This stairwell once led to the executive offices of the Ilford Company; the unframed photograph on the wall shows a kettle of photographic emulsion in the mixing process. In the heyday of the industry, this was an awe-inspiring image of high-tech in action. While the process and equipment used to make the stairwell photo were still operational at the time my own image of it was made, the stairwell image, originally in color, had faded to a monochrome version of its original self due to prolonged exposure to direct sunlight.

PHOTOGRAPH IN STAIRWELL, PAPER FINISHING BUILDING, ILFORD, MOBBERLEY, UNITED KINGDOM 2010

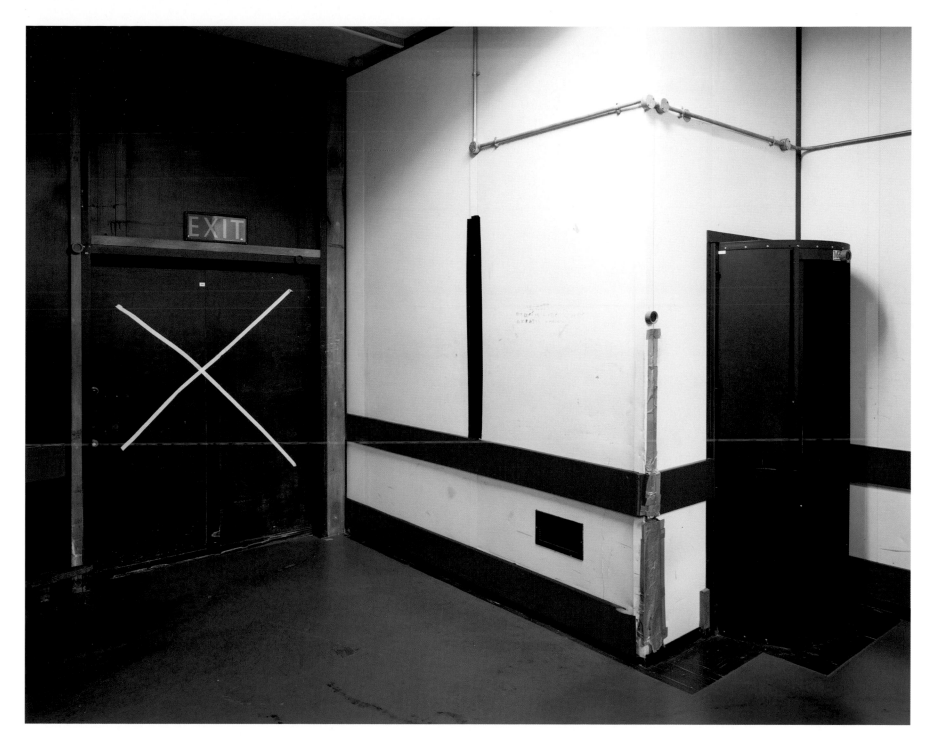

CUTTING ROOM, FILM FINISHING BUILDING, ILFORD, MOBBERLEY, UNITED KINGDOM 2010

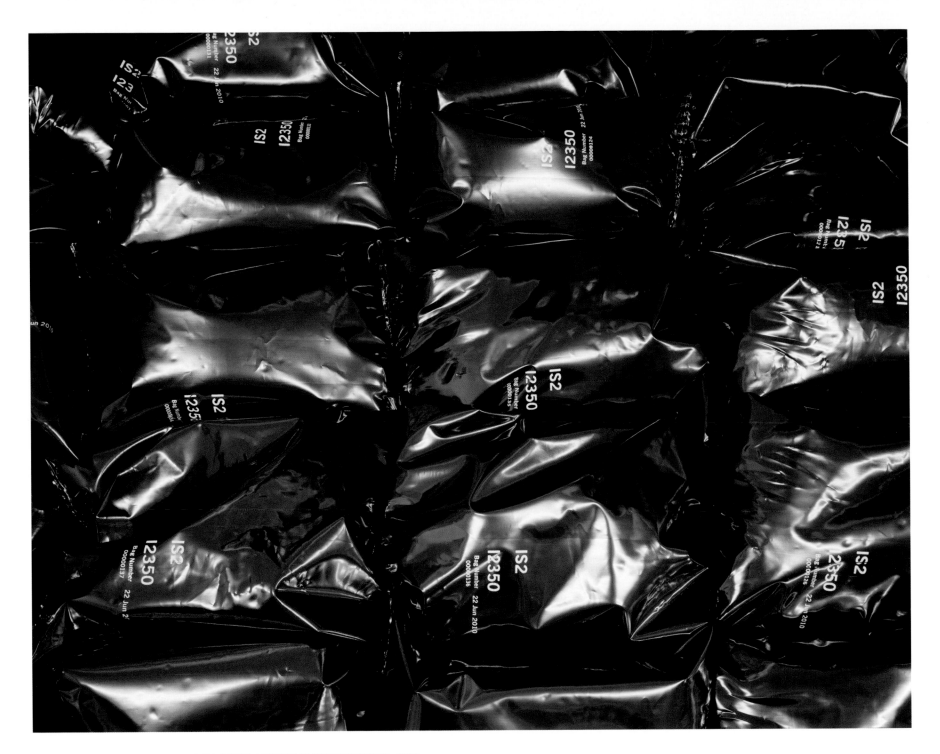

BAGS OF PHOTOGRAPHIC EMULSION, ILFORD, MOBBERLEY, UNITED KINGDOM 2010

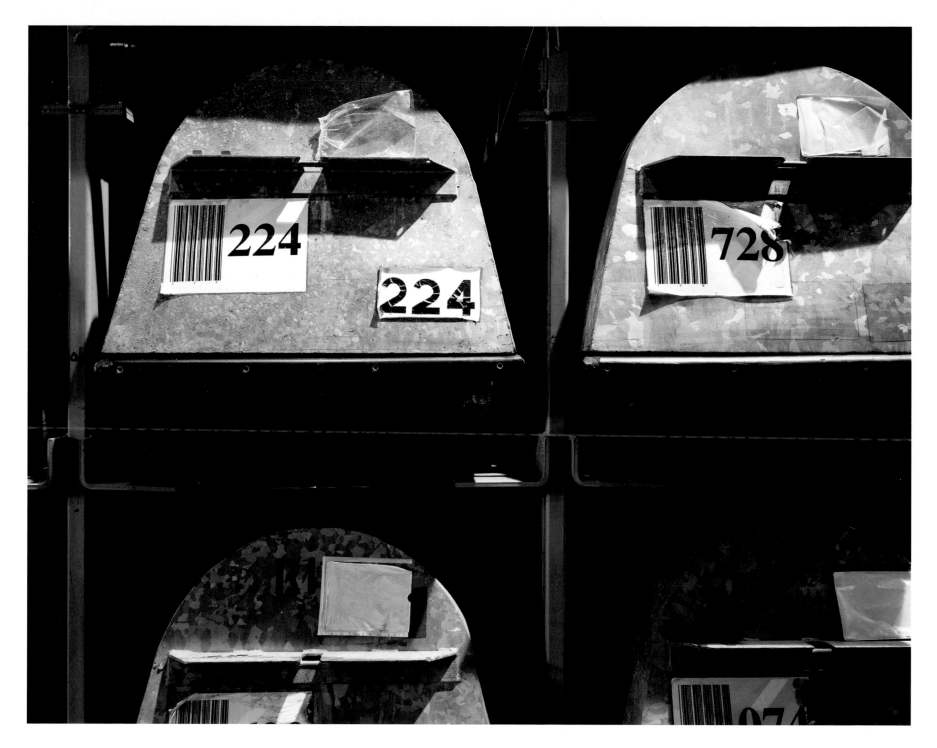

COFFINS OF FILM, FILM FINISHING BUILDING, ILFORD, MOBBERLEY, UNITED KINGDOM 2010

The Ilford Company first introduced flexible roll film in 1915, and today specializes in manu-facturing black-and-white photographic materials. Throughout the twentieth century, black-and-white film was a staple photographic product with myriad applications. Even after the introduction of color films in the 1940s, there continued to be a large demand for monochrome film from consumers, the media, government, and health sectors. The film's widespread popularity was due in no small part to the fact that it could be readily processed following step-by-step instructions in makeshift darkrooms, using chemistry supplied by the manufacturer. It was also the easiest material to manufacture. Unlike complicated, multi-layered color films, black-and-white entails coating a clear sheet of film with a single light-sensitive layer of silver salts suspended in gelatin.

In the twenty-first century most of film's applications have been usurped by faster, cheaper, and more flexible digital technologies. One of the last remaining markets for film is one that embraces its very limitations: artists. If film is to survive into the digital era, it is likely that it will do so in its simplest and original form, black-and-white, and be manufactured solely as an artist's material.

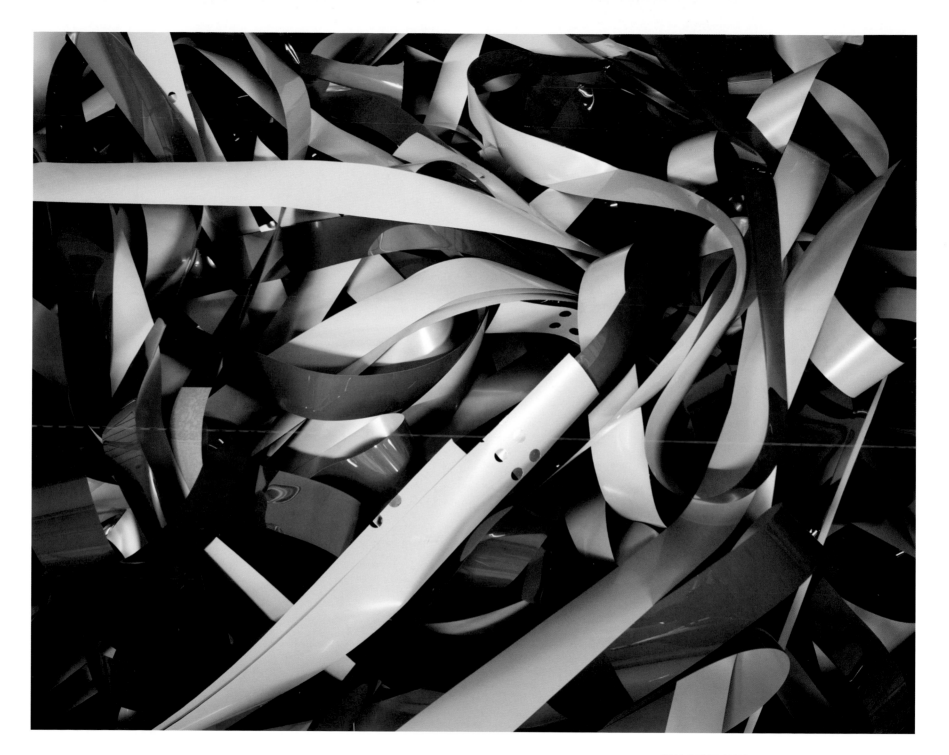

FILM, ILFORD, MOBBERLEY, UNITED KINGDOM 2010

In 1899, almost ten years after he created his sprawling Kodak Park factory complex in Rochester, George Eastman founded the Canadian Kodak Company, 150 miles to the north, in Toronto. By 1912, Kodak, which was rapidly expanding its global manufacturing operations, had purchased twenty-five acres of farmland on the edge of Toronto with the goal of building Kodak Heights. At its peak in the 1980s, this eighteen-building complex employed more than 2,000 people and was remarkably self-sufficient, generating its own electricity, maintaining a fire department, and providing on-site medical care for its workforce. Ironically, cameras were forbidden inside Kodak manufacturing facilities, because of the highly secretive nature of the company. Due to a complex division of labor, as well as a coded system of mixing chemical components, not even the plant workers knew how products were made. Employees sometimes referred to this guarded corporate paranoia as "working behind the silver curtain."

Throughout its history, Kodak Canada (as it became known in 1979) manufactured cameras, film, paper, and a host of related photographic products. Before it was shut down in 2005, the Kodak Canada complex was responsible for manufacturing all of the company's black-and-white film products for the western hemisphere.

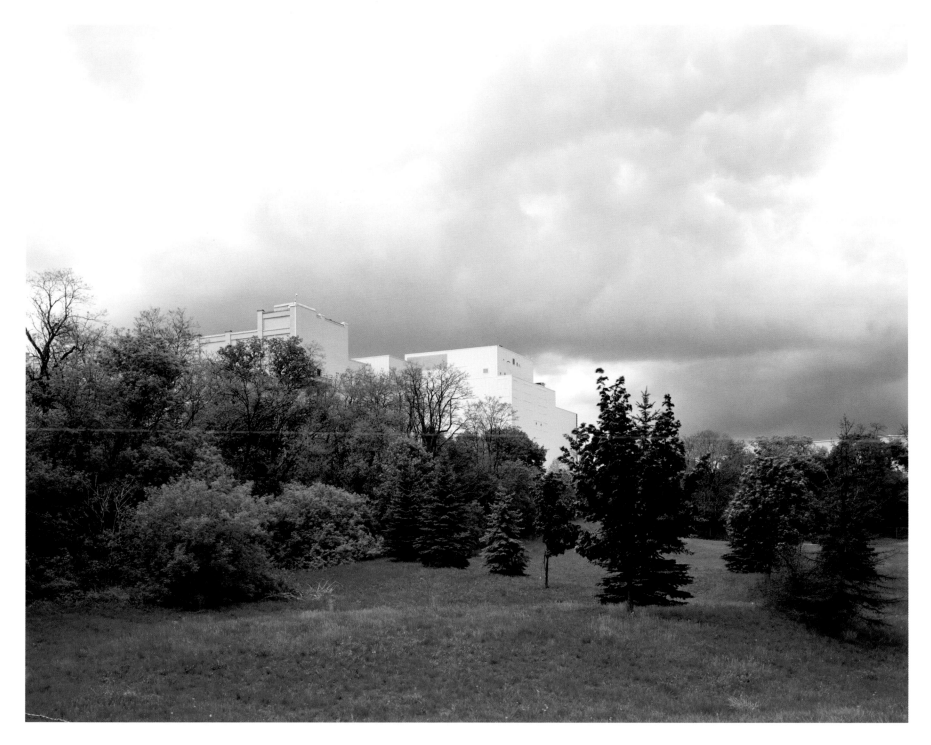

VIEW OF KODAK CANADA FROM EGLINTON AVENUE AND BLACK CREEK DRIVE, TORONTO 2005

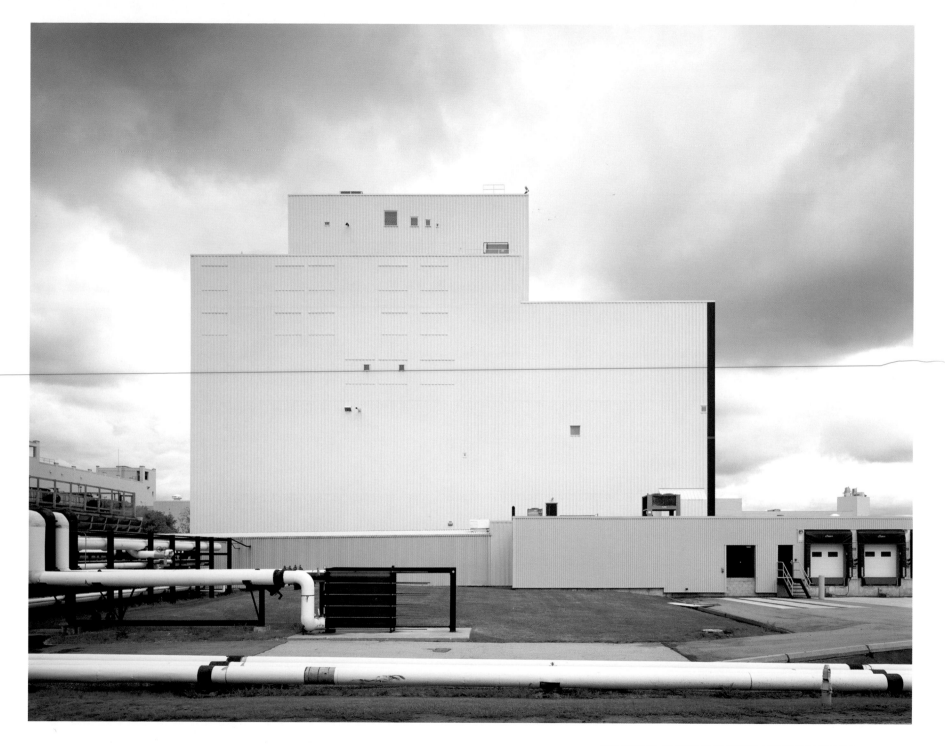

BUILDING 13, COATING FACILITY, KODAK CANADA, TORONTO 2006

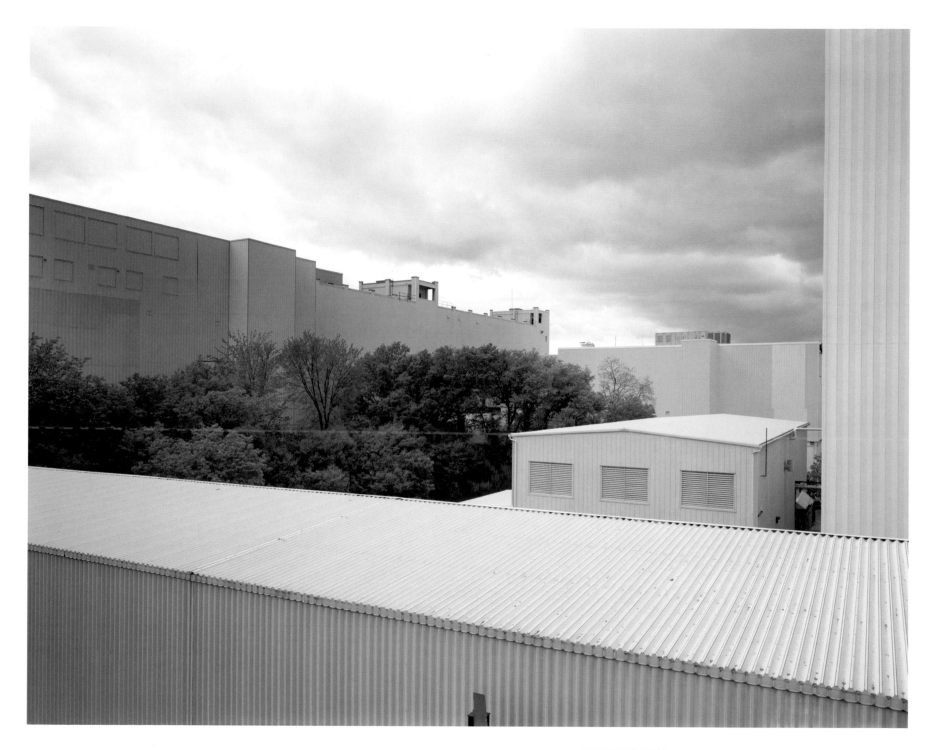

VIEW OF BUILDINGS 7, 8, 11, AND 13, KODAK CANADA, TORONTO 2006

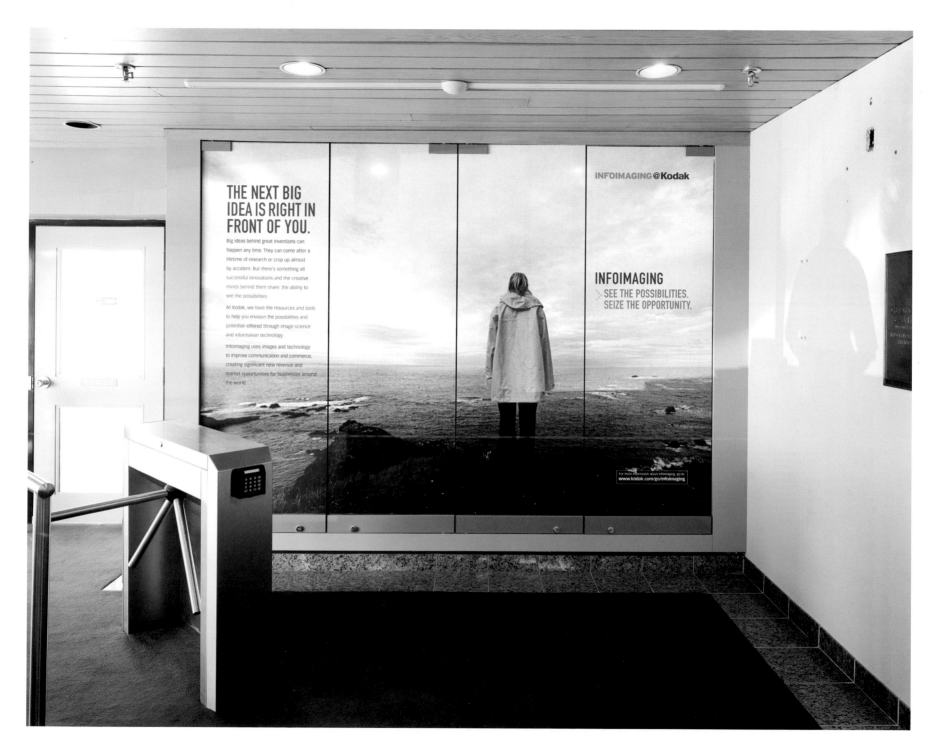

THE NEXT BIG
IDEA IS RIGHT IN
FRONT OF YOU.

Big ideas behind great inventions can
happen any time. They can come after a
lifetime of research or crop up almost
by accident. But there's something all
successful innovations and the creative
minds behind them share: the ability to
see the possibilities.

At Kodak, we have the resources and tools
to help you envision the possibilities and
potential–offered through image science
and information technology.

Infoimaging uses images and technology
to improve communication and commerce,
creating significant new revenue and
market opportunities for businesses around
the world.

INFOIMAGING@**Kodak**

INFOIMAGING
SEE THE POSSIBILITIES.
SEIZE THE OPPORTUNITY.

For more information about infoimaging, go to:
www.kodak.com/go/infoimaging

EXECUTIVE ENTRANCE, BUILDING 7, KODAK CANADA, TORONTO 2005

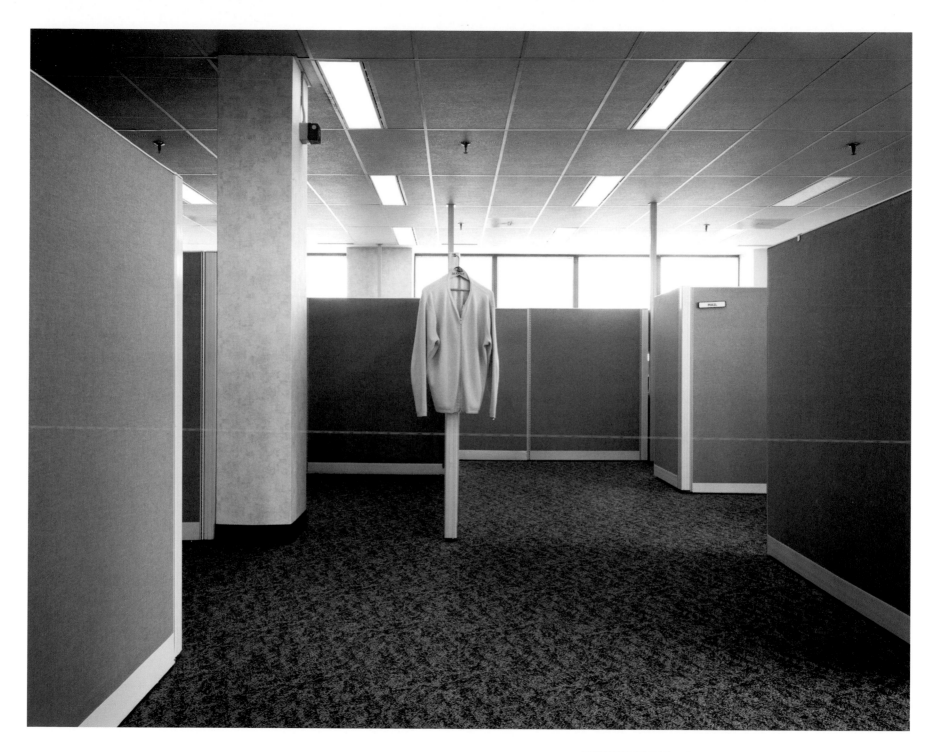

ADMINISTRATIVE AREA, BUILDING 7, KODAK CANADA, TORONTO 2006

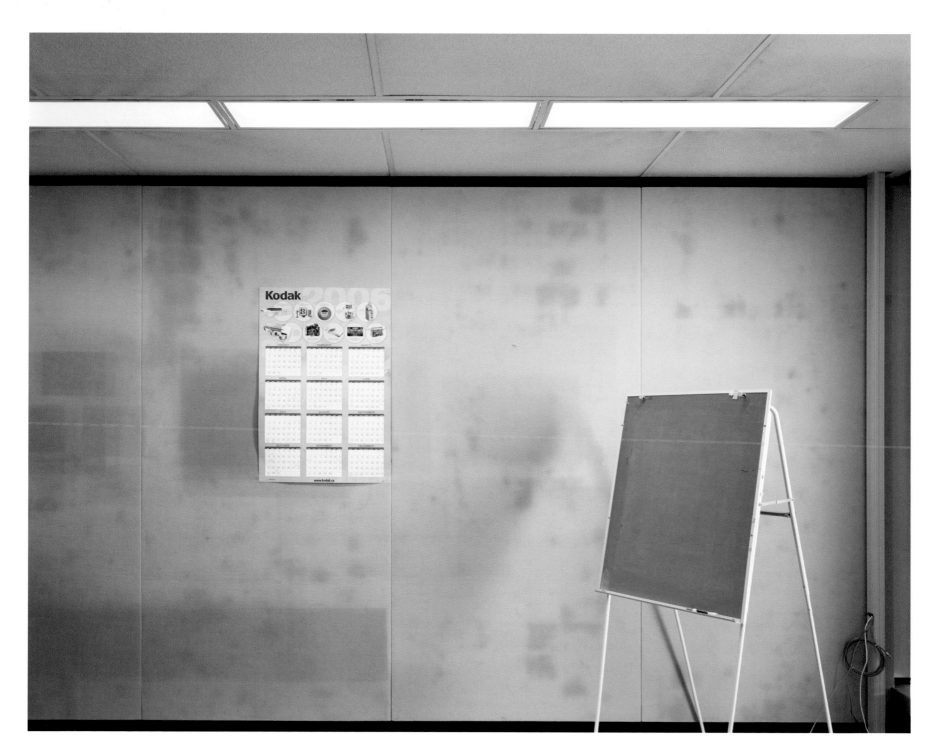

EXECUTIVE MEETING ROOM, BUILDING 7, KODAK CANADA, TORONTO 2006

In 2003, the sales of digital cameras worldwide surpassed those of film cameras for the first time. By April 2004, after a dramatic decline in film sales, Eastman Kodak was delisted from the Dow Jones Industrial Index, a position the company had held for seventy-four years. It was a clear signal that Kodak was losing its long-held position as a business titan. The next steps were wider-reaching: the multinational Eastman Kodak Company began closing down its numerous manufacturing complexes on four continents, and laying off tens of thousands of employees.

On December 9, 2004, Kodak Canada held a meeting with its employees to inform them that the plant would be closed, decommissioned, and demolished in a matter of months. On the last day of manufacturing, June 29, 2005, the workers met in the West Parking Lot to have a group photo taken. After a photographer in a helicopter hovering above the site had captured the image, they picked up gift bags filled with Kodak products, and went home.

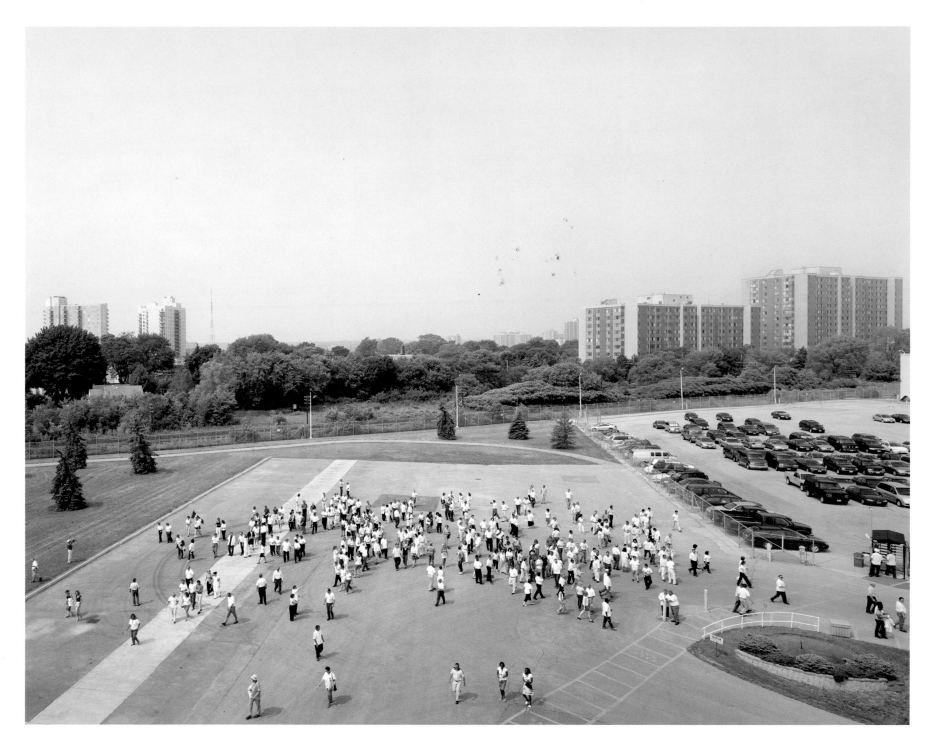

END OF EMPLOYEE MEETING, WEST PARKING LOT, LAST DAY OF MANUFACTURING OPERATIONS, KODAK CANADA, TORONTO JUNE 29, 2005

Although some photographic films and papers could be handled in subdued ("safe") light, most films were manufactured, cut, and packaged in absolute darkness. For this reason, many of the buildings were filled with darkened, black-painted rooms, often thousands of square feet in size, to meet the needs of large-scale production.

The building interiors were divided into a complex series of hallways and entrance and exit passages to accommodate the traffic of workers who had developed an equally complex system for working in, and finding their way through these dark areas without incident. While the Kodak Company had a long history of employing blind workers who were at ease in the pitch dark, most others whistled or called "Watch out!" to their peers as they made their way to their workstations.

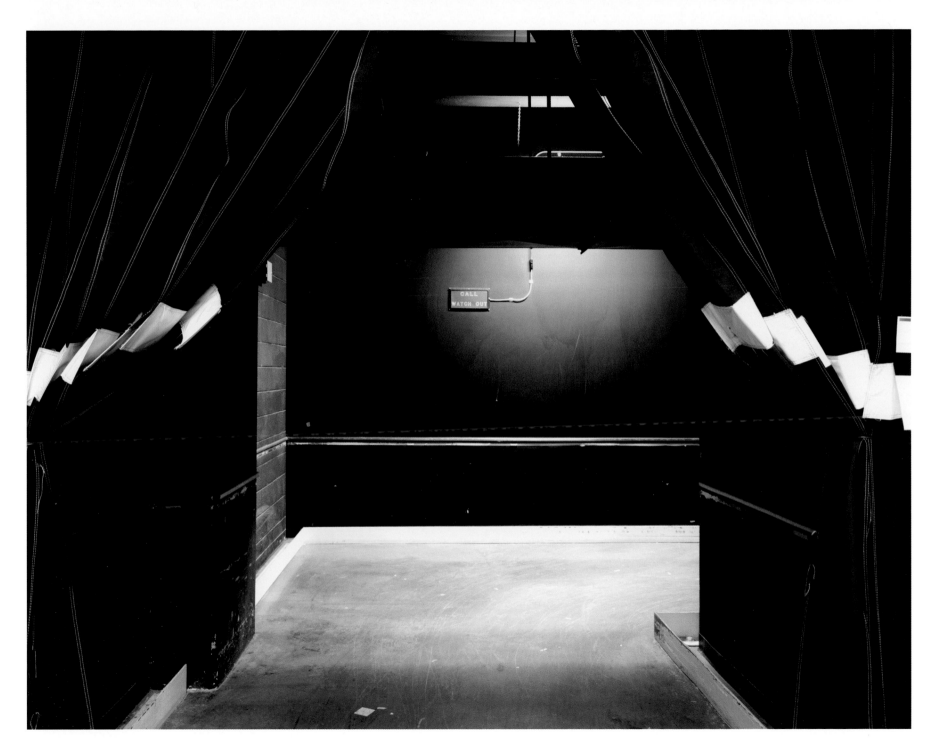

DARKROOM, BUILDING 3, KODAK CANADA, TORONTO 2005

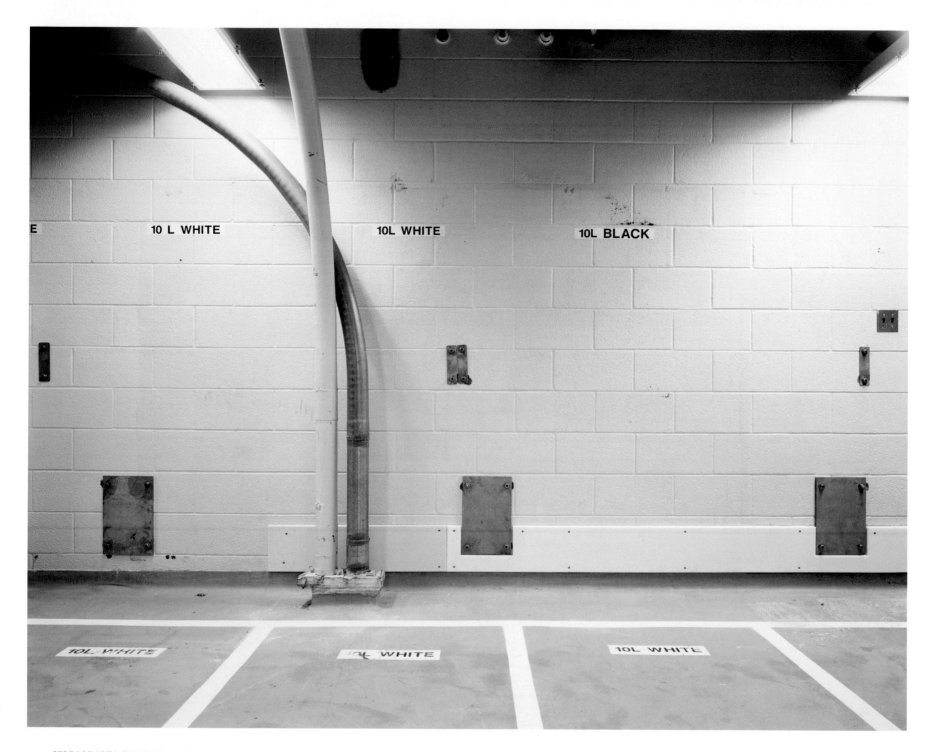

STORAGE AREA, BUILDING 10, KODAK CANADA, TORONTO 2006

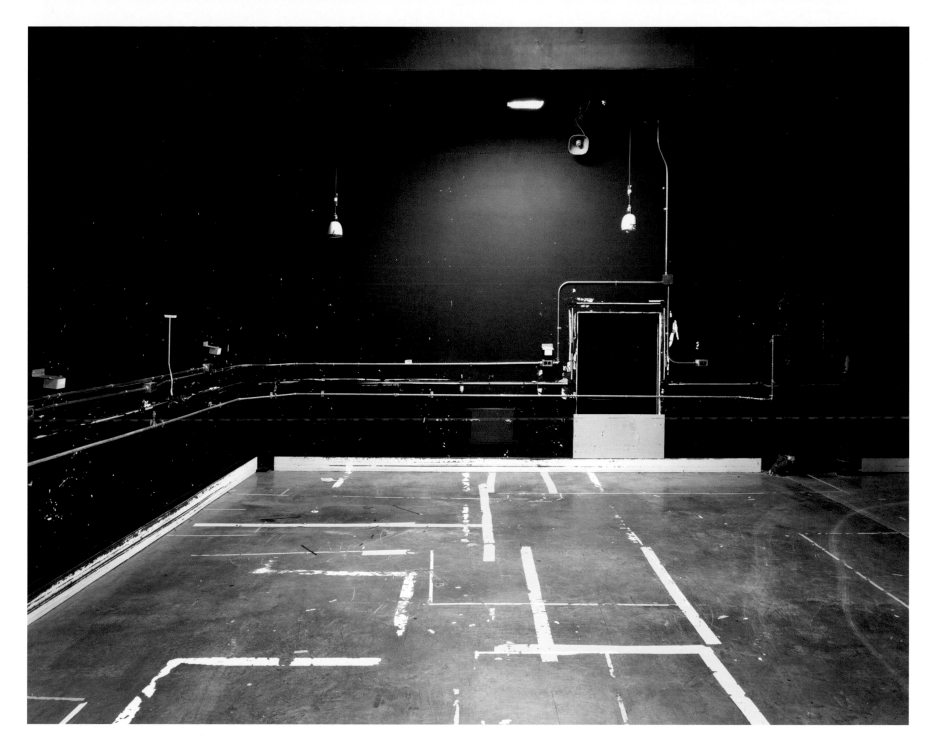

DARKROOM, BUILDING 10, KODAK CANADA, TORONTO 2006

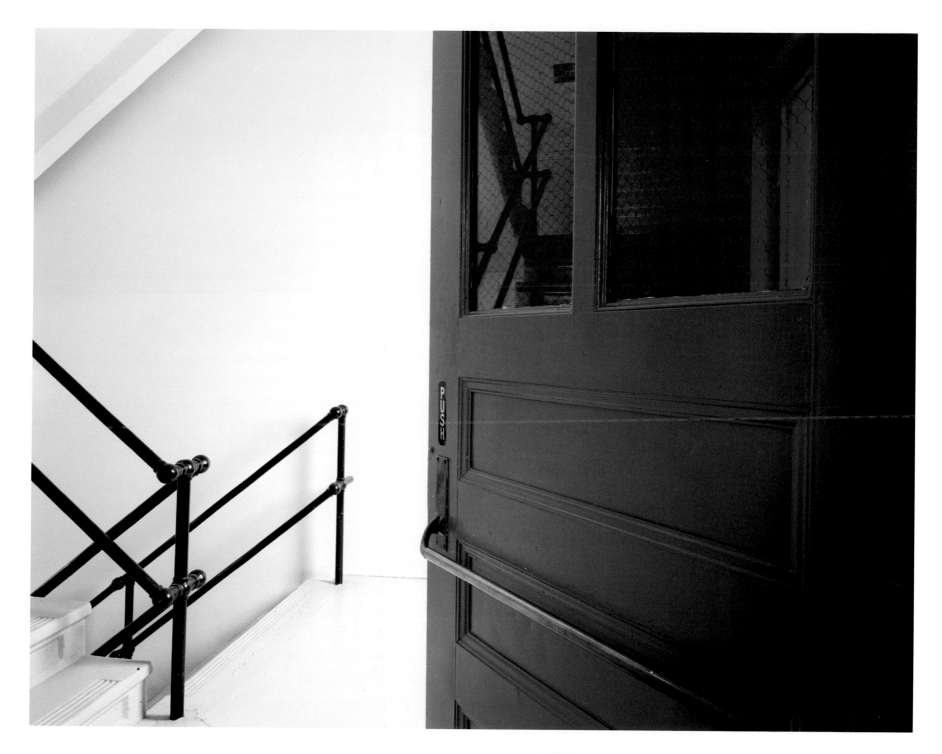

ENTRANCE TO CUTTING ROOMS, BUILDING 10, KODAK CANADA, TORONTO 2005

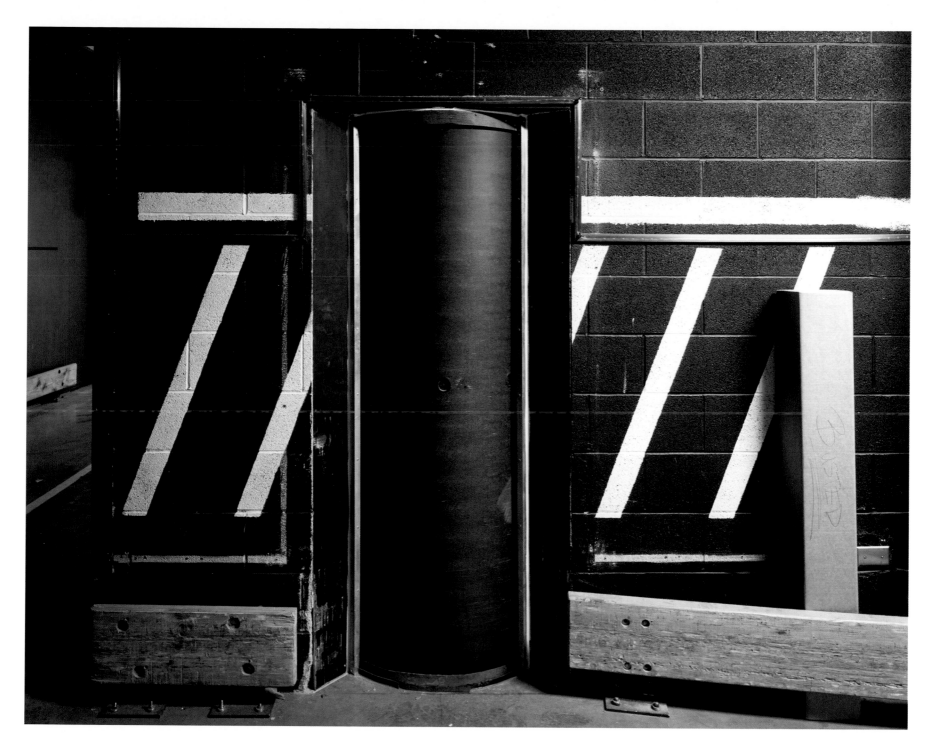

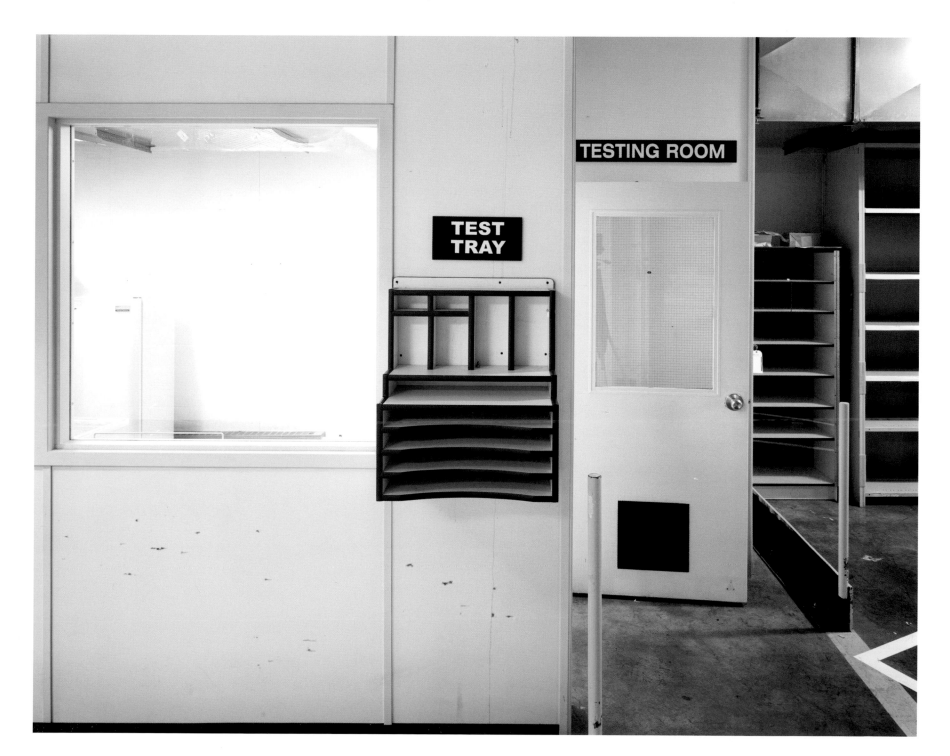

TESTING ROOM, BUILDING 11, KODAK CANADA, TORONTO 2005

In building the Kodak Company, George Eastman was obsessed with ensuring that his employees were satisfied in their jobs; he strove to avoid unions by offering a host of benefits that encompassed profit sharing, retirement savings plans, and subsidies to health and education. These practices were also followed at Kodak Canada, including the company's suggestion system, which rewarded employees who submitted ideas to improve plant operations with cash bonuses. Company records indicate that in 1918, P. G. Dryden was given $3.00 for suggesting that red lights be installed over the fire alarm boxes in the darkrooms, and in 1920, B. Smith was given $1.00 for suggesting a clock be installed in the employee dining room. That same year T. Adams received $25.00 for proposing that a lock be installed on the elevator gate.

To be an employee at Kodak Canada was to be a part of an active community that came complete with its own sports teams, theater troupes, and, of course, the Kodak Heights Camera Club. In 1940, the company constructed Building 9, dedicated to the leisure time of its employees. Located at the end of Photography Drive, Building 9 housed a cafeteria, auditorium, clubroom, locker room, camera studio, darkrooms, and managers' dining area. In addition to Building 9, there was also a baseball diamond and tennis courts on the grounds.

Most Kodak employees, who lived in the surrounding Mount Dennis neighborhood, stayed with the company for the duration of their working lives. It was common to have two or more generations of one family working in the plant at the same time.

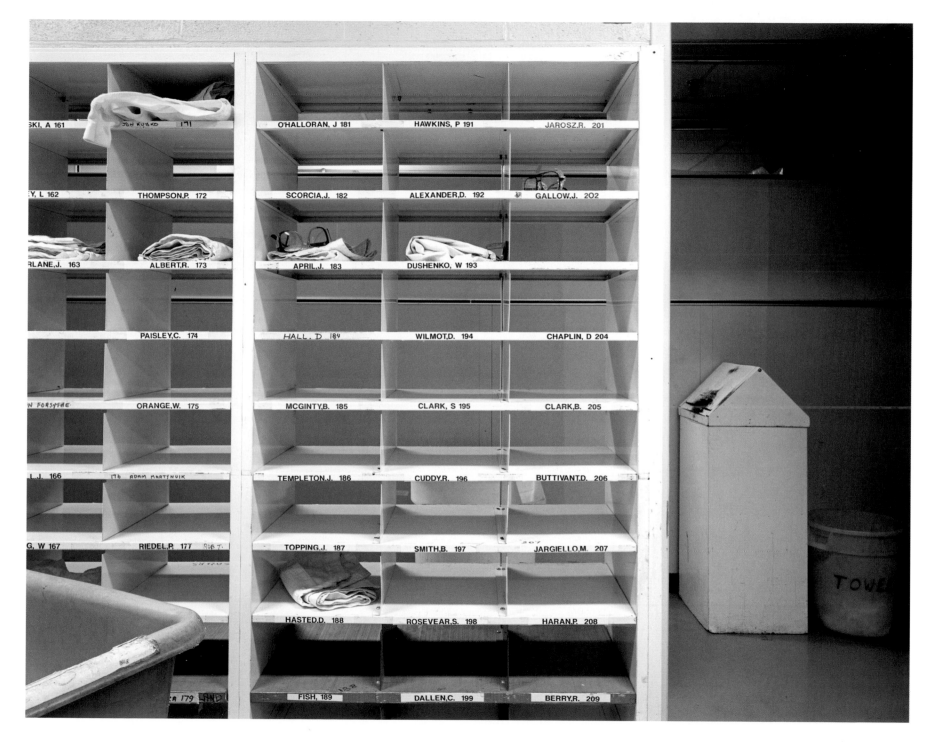

EMULSION ROOM, BUILDING 13, KODAK CANADA, TORONTO 2005

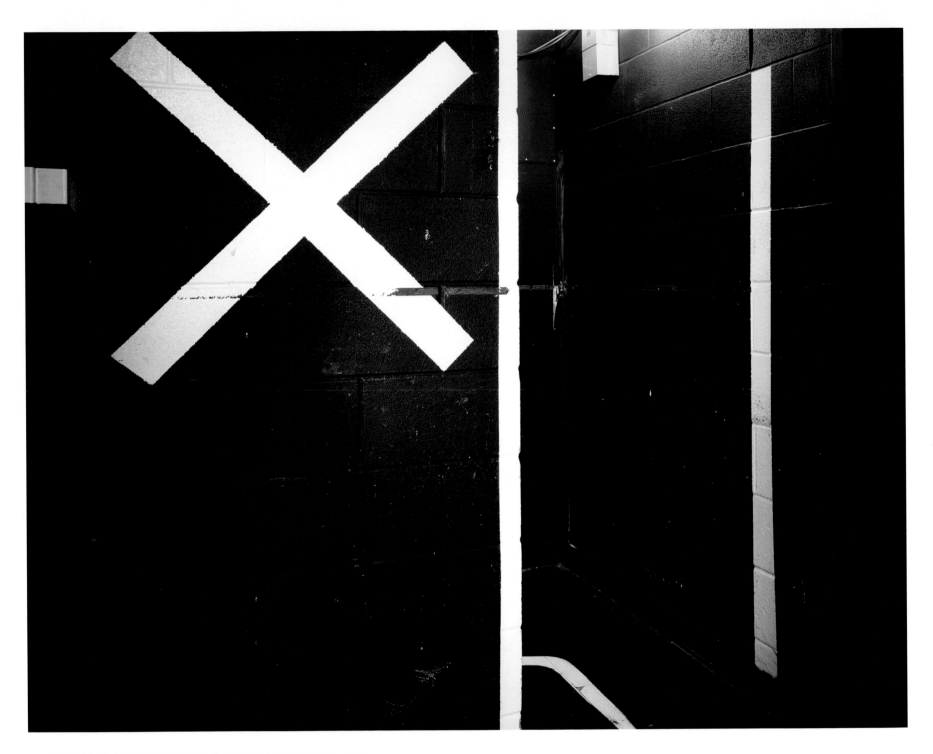

ENTRY TO COATING AREA, BUILDING 13, KODAK CANADA, TORONTO 2005

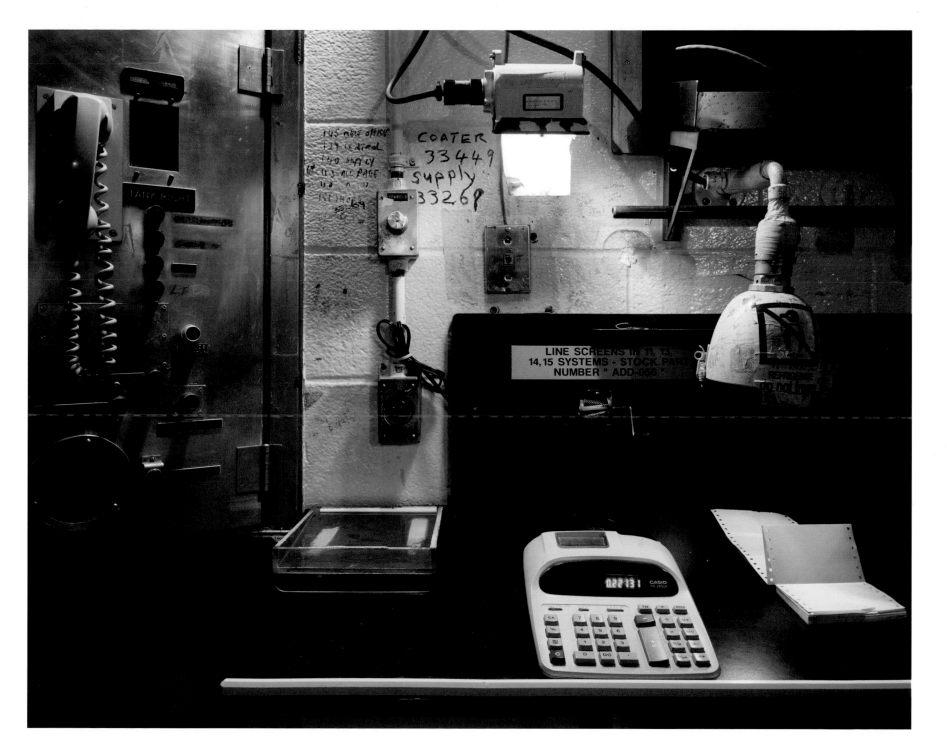

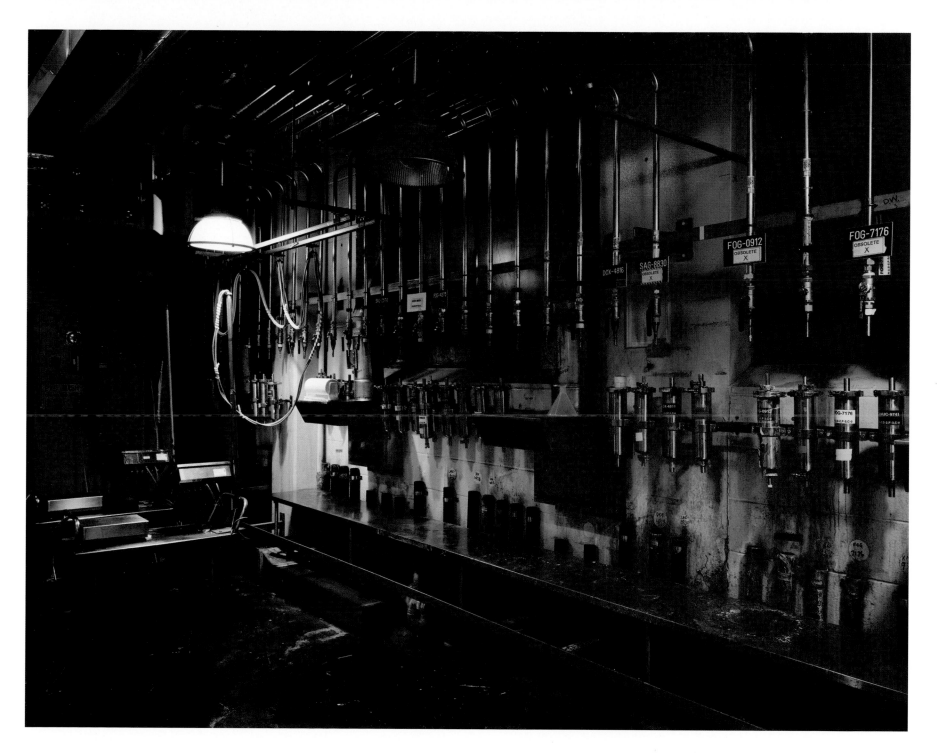

CHEMICAL MIX ROOM, BUILDING 13, KODAK CANADA, TORONTO 2006

To see the inner workings of a photographic coating facility is to get a concentrated glimpse into the complexity of the manufacturing processes used to make film. Making the color negative film used to create the photograph on the opposite page, for example, required a system capable of laying down eight light-sensitive chemical layers, along with an additional six non-imaging layers, onto a roll of polyester film. Each layer had to be kept within one percent of its desired thickness; the total thickness of all the combined layers added up to approximately half the thickness of a single human hair. This minor miracle had to be accomplished in absolute darkness to punishingly high tolerances, with stringent control of all dust and chemical contaminants. The machines responsible for the process were designed to run twenty-four hours a day, producing up to fifty master rolls of film, each over four feet wide and more than a mile in length. After peering behind "the silver curtain," the phrase "economy of scale" comes into unique focus; it's difficult to imagine how this process could ever be done successfully on a smaller scale. The photograph on the opposite page shows the back end of the hopper, the device used to coat film in Building 13.

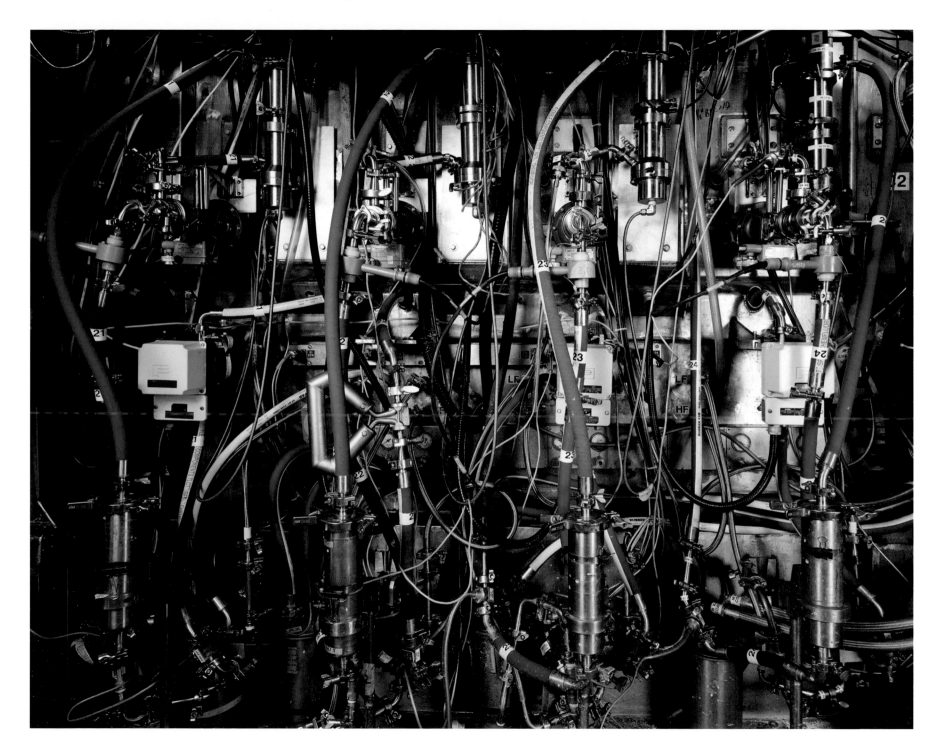

THE HOPPER, BUILDING 13, KODAK CANADA, TORONTO 2005

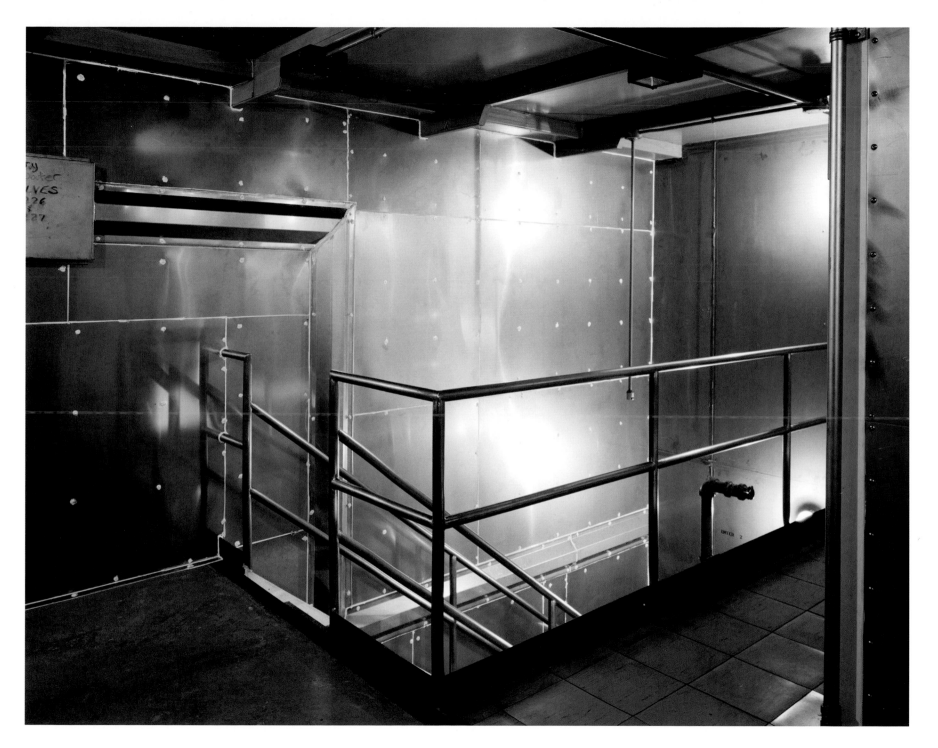

STAIRWELL TO DRYING ROOMS, BUILDING 13, KODAK CANADA, TORONTO 2005

In 2005, the employee darkroom at Kodak Canada still displayed a warning to staff (transcribed
above) about the proper use of the facilities. By this time, Kodak employees had long stopped
using the darkrooms, even though photographic materials were available to them at no cost.
The photographic process, like the company's paternalistic by-laws, had lost their relevance in
the new millennium. By 2009, the sign had been torn from the wall, with only a few caricatures
drawn where the words had once been.

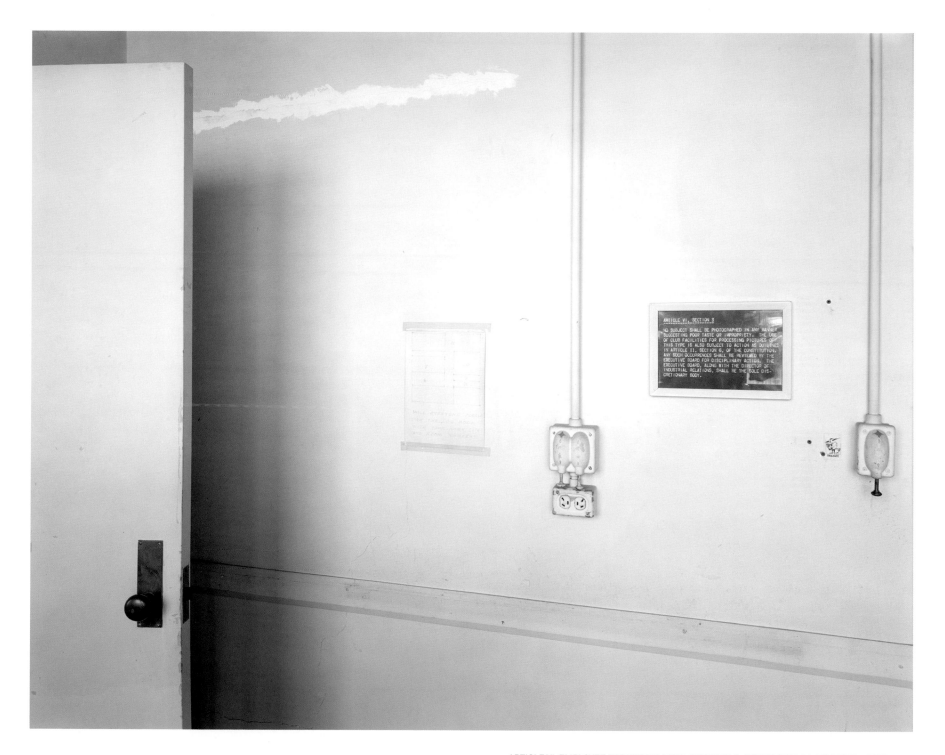

ARTICLE VI, EMPLOYEE DARKROOM AREA, BUILDING 9, KODAK CANADA, TORONTO 2005

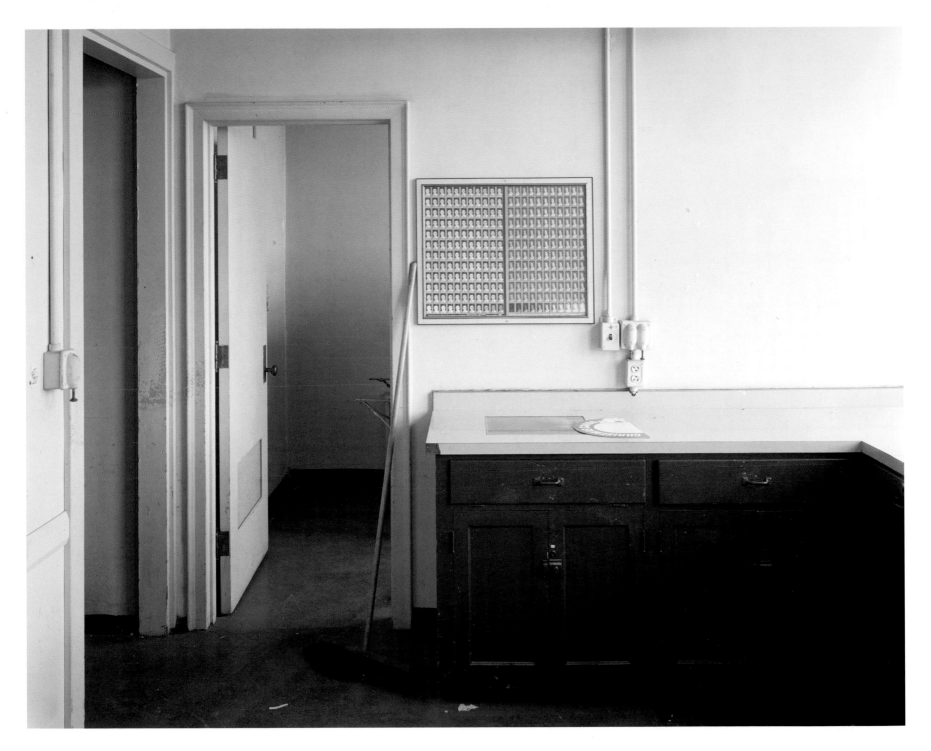

EMPLOYEE DARKROOM AREA, BUILDING 9, KODAK CANADA, TORONTO 2005

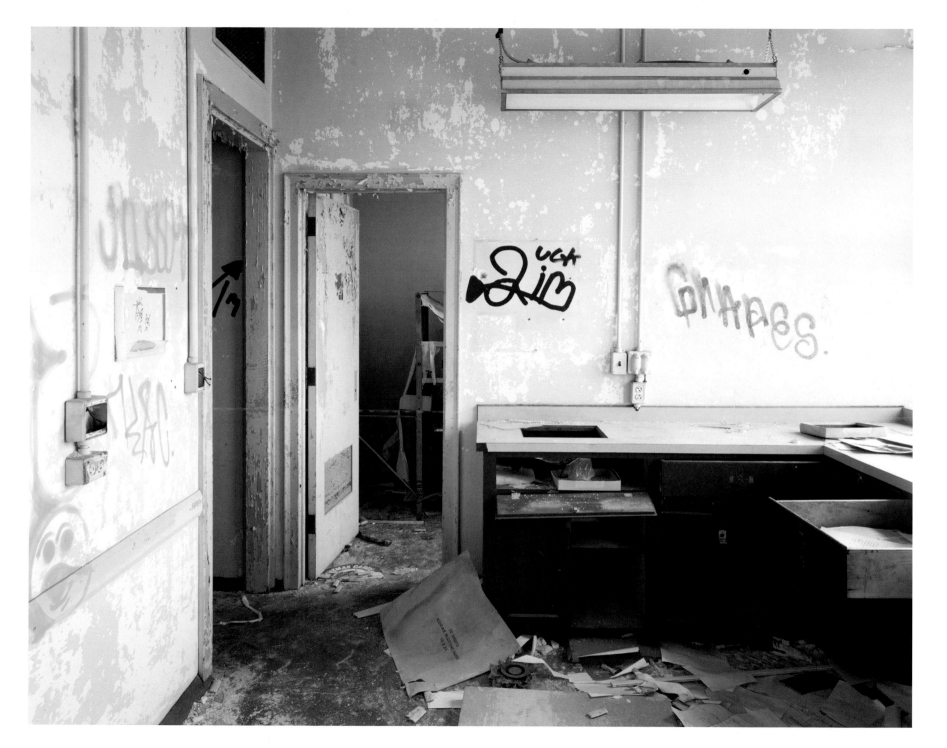

EMPLOYEE DARKROOM AREA, BUILDING 9, KODAK CANADA, TORONTO 2009

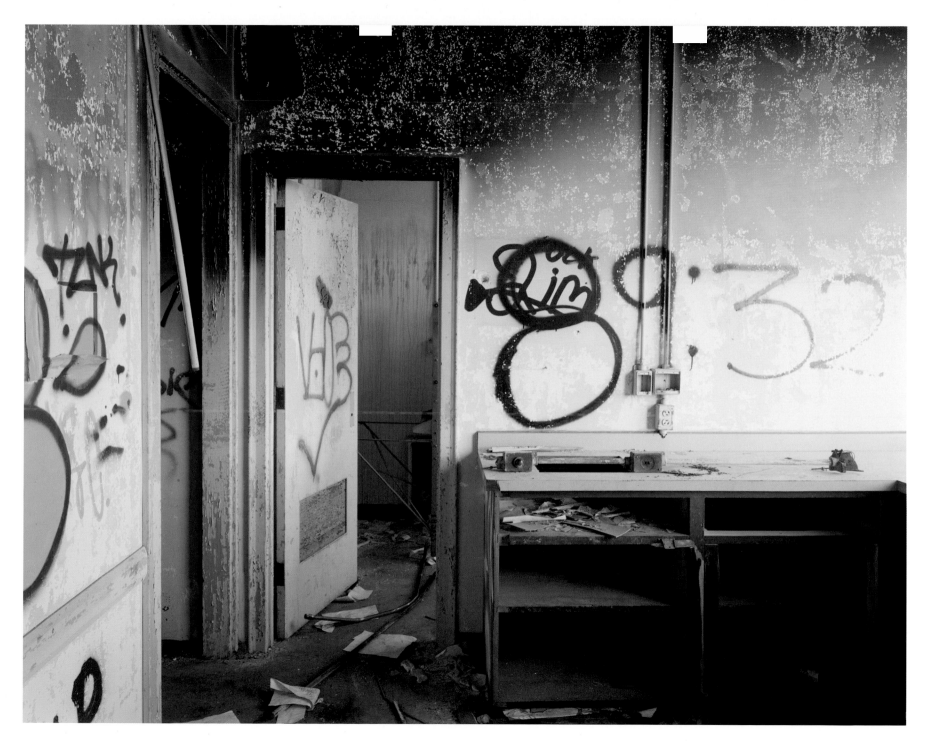

EMPLOYEE DARKROOM AREA, BUILDING 9, KODAK CANADA, TORONTO 2011

Long a symbol of Kodak Canada's corporate presence in the Mount Dennis neighborhood, the gymnasium was used by company employees as well as a host of local community groups for a variety of functions. This multifunctional space served as sports venue, theatrical stage, and movie theater, as well as auditorium for fundraising events and educational evenings. Like all of the Kodak buildings, and the property in general, it was maintained to the highest standards since it first opened in 1940.

When the Kodak Company sold the property to a land developer in 2007, the City of Toronto insisted that Building 9 be saved so that future generations could become familiar with the Kodak legacy. As each of the seventeen office, manufacturing, and warehouse buildings around it were demolished, Building 9 was rediscovered by a younger generation who adopted the gymnasium as a late-night destination for raves and impromptu art events. Cell-phone photos at such events were *de rigueur*; film and the analog culture that had built the building that housed them were now just a dream.

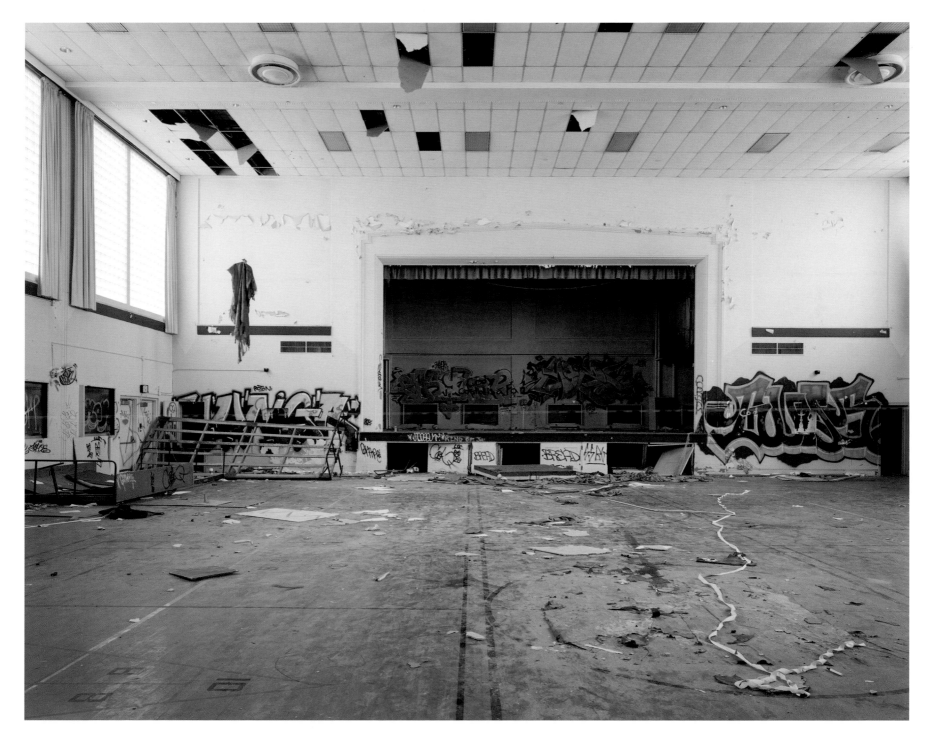

GYMNASIUM, BUILDING 9, KODAK CANADA, TORONTO 2009

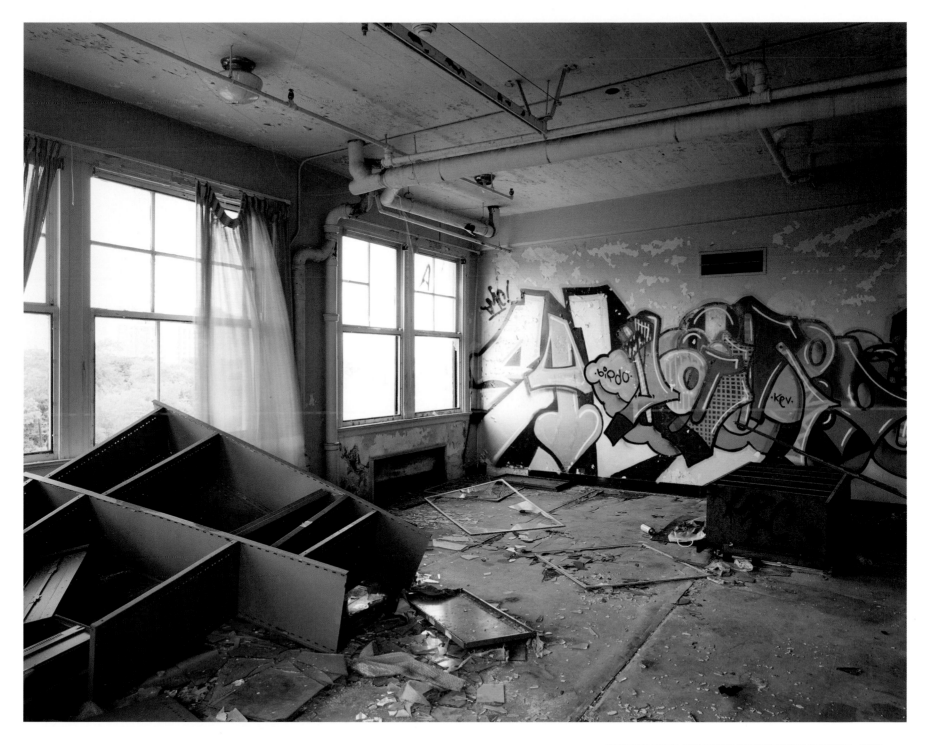

ARCHIVES ROOM, BUILDING 9, KODAK CANADA, TORONTO 2009

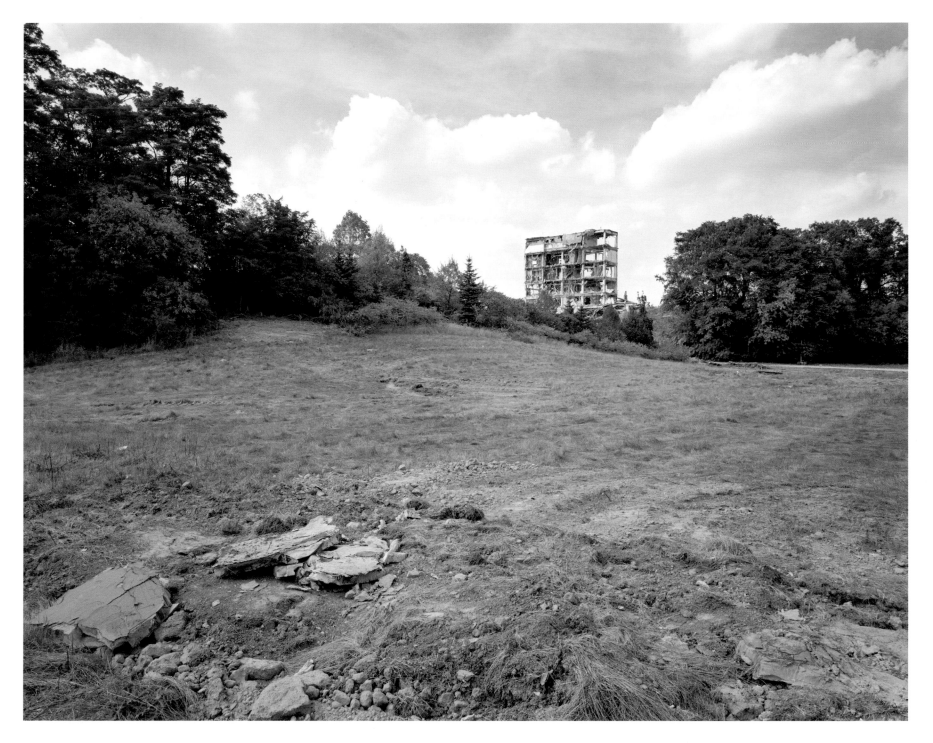

DEMOLITION OF BUILDING 13, KODAK CANADA, TORONTO 2007

TECHNICAL NOTES

The photographs in this book were created with a Toyo 45A Field Camera using a 90mm Sinar Sinaron, f/4.5 lens, a 180mm Horseman Topcor, f/5.6 lens, and a 210mm Sinar Sinaron S, f/5.6 lens. Three different types of chromogenic negative 4" x 5" sheet film were used to make the images: Kodak Portra NC 160, Kodak Portra VC 160, and Fujicolor NPL 160. Polaroid Type 55 black and white positive/negative film was used as a test fim to determine proper exposure and focus. At the end of the project in 2011, only Kodak Portra 160 (a newer version of the Portra NC 160 and VC 160 films) remained on the market.

The film was processed by the following professional photo labs: Steichenlab, Toronto (closed in 2006); Toronto Image Works Ltd., Toronto; Metro Imaging, London, U.K.; and Pixel Grain, Berlin, Germany using the Kodak C-41 process. Each negative was scanned using an Imacon Flextight 848, X1, or X5 film scanner. Final digital files were printed on Kodak Ektacolor Endura paper using a Chromira roll-to-roll printer. The exposed chromogenic paper was developed in a Colex color processor using the Kodak RA-4 process.

All photographic sheet film is identified with a system of coded manufacturer's notches that are cut into the top right corner of the emulsion (light sensitive) side of the material. These notches, which can be read by touch in total darkness, are also used to recognize the emulsion side of the film when it is loaded into holders prior to a shoot.

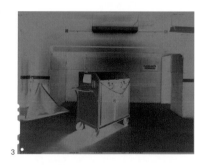

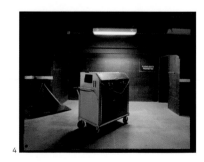

1 Base side of a 4" x 5" sheet of Fujicolor NPL 160 film
2 Emulsion side of a 4" x 5" sheet of Fujicolor NPL 160 film
3 Processed Fujicolor NPL 160 film color negative of **Darkroom, Building 11, Kodak Canada, Toronto** 2006
4 Contact print on Kodak Professional Endura Photographic Paper, F Surface of **Darkroom, Building 11, Kodak Canada, Toronto** 2006

BIOGRAPHICAL NOTES

As an artist working in photography, Robert Burley has sought to describe and interpret the built environment in which he lives. His work often explores the transition between city and country through projects such as *ORD: O'Hare Airfield*, *Viewing Olmsted*, and the *Great Lakes*. He has also photographed urban spaces and structures through commissioned and self-directed projects that include *Instruments of Faith*, *House / Home*, and *The Places of Glenn Gould*. Burley's photographs have been extensively published and exhibited, and can be found in numerous museum collections including the National Gallery of Canada, Musée de l'Elysée, George Eastman House–International Museum of Photography and Film, Canadian Centre for Architecture, and the Musée des beaux-arts de Montréal. Books featuring the work of Robert Burley include *Viewing Olmsted: Photographs by Robert Burley, Lee Friedlander and Geoffrey James*; *O'Hare: Airport on the Prairie*; and *The Death of Photography: Robert Burley, Michel Campeau and Alison Rossiter*. Burley has lectured about his work through the Rouse Visiting Artist Program at Harvard University and the Senior Mellon Fellowship Program at the Canadian Centre for Architecture.

Burley has begun to create public installations that combine photography with architecture which have been featured at major festivals including: Scotiabank Contact Photography Festival (2008) in Toronto and Le Mois de la Photo à Montréal (2009). Robert Burley lives in Toronto with his family and currently holds the position of Associate Professor at Ryerson University's School of Image Arts.